JOHN McCORMICK | landscapes

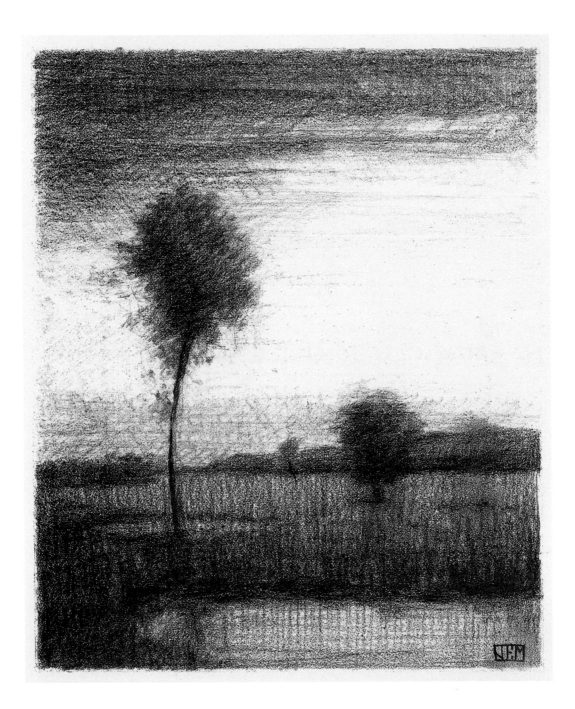

JOHN McCORMICK | landscapes

Essays by Susan Hillhouse & Ron Glowen

HORSE HILL PUBLISHING | CORTE MADERA, CA

Published in conjunction with exhibitions in 2001 at
The Triton Museum of Art, Santa Clara, CA
The Munson Gallery, Santa Fe, NM
Lisa Harris Gallery, Seattle, WA

Designed by Marcus Associates
Photography by Jan Gauthier

Published by:
Horse Hill Publishing
P.O. Box 592
Corte Madera, CA 94976-0592
website: www.johnmccormick.com

First Edition
ISBN 0-9711945-0-5
Library of Congress Catalog Control Number
2001091140

Printed in Hong Kong

Cover: Near Marshall (Tomales Bay) oil on linen, 48 inches x 48 inches, 2001

Title page: Delta #2, study charcoal on paper, 12 inches x 9 inches, 1996

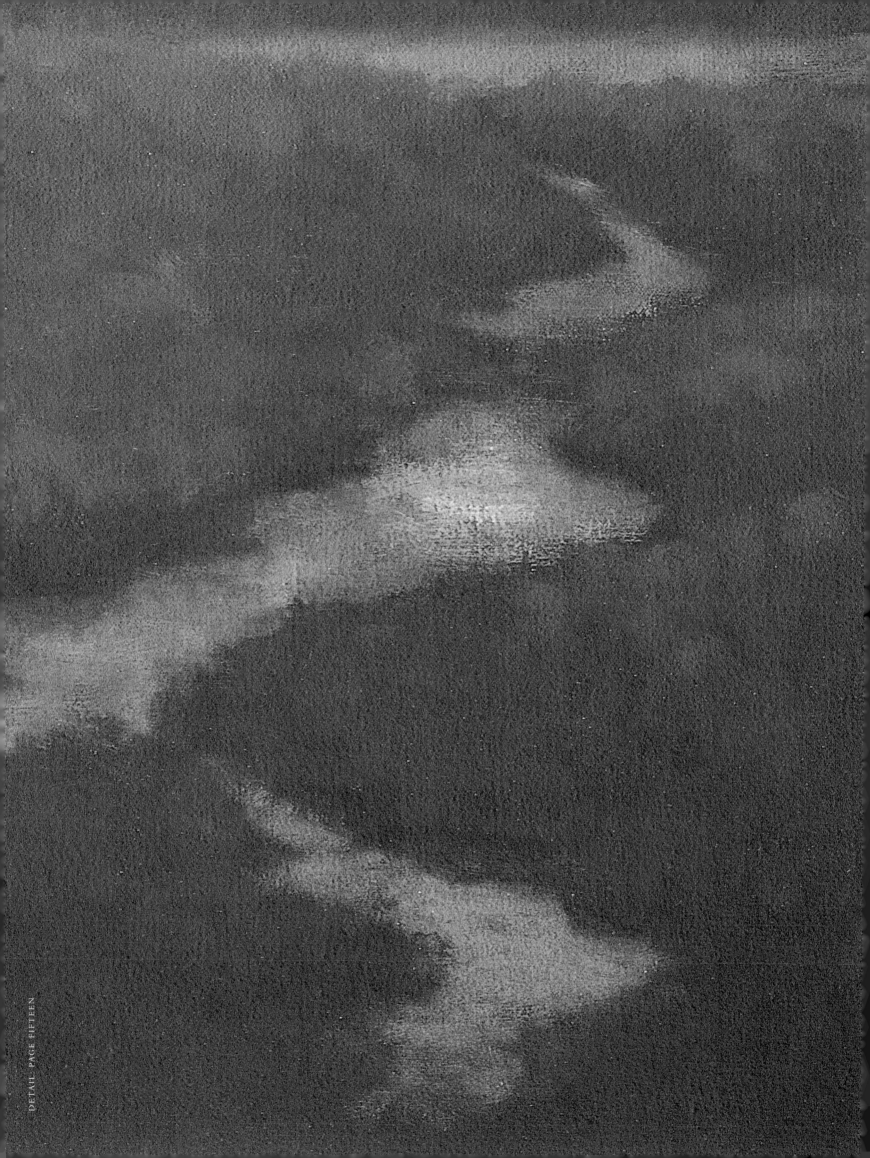

SUSAN HILLHOUSE

Chief Curator, Triton Museum of Art

◦⌐

SEPARATION

YOUR ABSENCE HAS GONE THROUGH ME

LIKE THREAD THROUGH A NEEDLE.

EVERYTHING I DO IS STITCHED WITH ITS COLOR.

W.S. MERWIN

Nature is the source, sustenance and departure point for John McCormick's stunning, mist-laden landscape paintings and drawings. Prelapsarian and bucolic in feeling, they suggest real and imagined, material and ethereal, familiar and foreign places. Inhabiting a metaspace of internalized experience, McCormick creates work that is evocative of the mysterious and the fragile in nature and, at the same time, he shows a continued interest in aesthetic problems of spatial division and spatial relationships coupled with a legitimate interest in the act of painting.

McCormick's childhood spent in St. Paul, Minnesota gave him access to the lakes and waterways that sometimes appear in his moldable, reinventable landscapes. Relying on the transition and mutation of cumulative visual experience, he explores themes of memory and reclamation. In pursuit of the abstract, the timeless, and the transcendently rational, his work speaks to cultural complexity. Expressing the energy and motion of the scenery through internal forces individuates his experiences and expands traditional painting with flashes of poetic thought. Located in the intersection of illusion and reality, McCormick's painting is as much about landscape painting as it is about the landscape.

Executed with finesse and distilled to a vapor of feeling, his landscape work appeals first to the emotions and second to the intellect. Close to McCormick's heart is his interest in protecting the environment; the results of this concern are manifested in work that provides a refuge of beauty and magic. Clearly, too, his artwork demonstrates an interest in reintroducing the idea of the sublime in landscape painting.

McCormick's charcoal drawings and studies have areas of rich, dark shadows and subtle shadings that are texturally complex and bring to mind the velvety dark ink found in a Rembrandt etching. Citing Gottardo Piazzoni, Giuseppe Cadenasso, as well as the modern influences of Ad Reinhardt and Mark Rothko as sources of inspiration for both his drawings and paintings, McCormick continues "to explore the polytonal qualities of color and light." He says that this work is "historically connected in terms of technique, and the pictures are a byproduct of the process of engagement."

This body of work, which he calls "studio inventions," seems to arrive at illumination through a glowing candle-sun. Working with a reduced palette of subtle colors, McCormick renders a light that diffuses and maps out a terrain void of the manufactured intrusions of contemporary society. The absence of anything vulgar or harsh lends the work a sure serenity, allows for a few, fleeting melancholy moments, and permits a viewing experience capable of recharging a weary mind.

Often crepuscular in mood, the color-wonderful hues of muted, misty greens, sundried golden yellows and watery, cloudy blues bring to mind the Portuguese word *saudades,* nostalgia for something that never was, or perhaps a promise unrealized. The unannounced memories of John McCormick's collective inventions have an ancestry in landscape that is completely present and far, far away.

RON GLOWEN
Conception and Suffusion: John McCormick's Landscape Paintings

FIRST AND FOREMOST, THE WORK OF ART IS A CONCEPTION. IT IS THE PRODUCT OF AN ARTIST'S COMPREHENSION, CONCEPTION, FORMULATION AND EXECUTION. AT A TIME WHEN ART MAKING IS DRIVEN BY A MYRIAD OF EXTERNAL FORCES, RANGING FROM POLITICS TO ECONOMICS AND CAREERISM, SUCH SENTIMENTS ARE OFTEN LOST OR SIMPLY TAKEN FOR GRANTED. BUT THE CHARACTERISTICS OF CONCEPTION GO INTO EVERY WORK OF ART, FROM THE MOST TRADITIONAL TO THE MOST AVANT-GARDE. IT'S THERE, EVEN IF INTENDED OR STATED OTHERWISE.

John McCormick's tonalist paintings of landscape are conceptions. That is the essence, if you will, of his esthetic statement. He does not, however, make it so obvious as I have proclaimed it here. There has been a gestation—a period of thoughtful and deliberate development, of fruitful investigation and reflection—that matured into McCormick's desire to paint the image of landscapes. About a decade ago, he migrated from making colorful abstract paintings to these serene and intimate landscape views with their reductive palette, crafted brushwork, orchestrated compositions and constructed spaces. He acknowledges that he was starting to see landscape forms emerging from his non-objective abstraction, and decided to follow that path. This was not a strategic or retrograde move, but rather the recognition of the natural and intuitive process of artistic conception that was at work. McCormick refers to his landscape paintings as "studio inventions," which might seem like an odd thing to consider given that landscape is external to the studio. (But it begs the question—is abstraction therefore the opposite, the internalization of the studio environment?)

McCormick's landscapes seem to be about a particular environment or place, and are sometimes titled as if it were the view of an actual place or thing in the landscape. If they are,
then it is only through a continual absorption of a particular place that has been suffused into memory and experience. Suffused means "to spread over, to tint with liquid, light or color." Suffusion succinctly describes McCormick's painterly technique and style. But the suffusion I am referring to is something that I can relate to, stemming from my own esthetic perceptions of landscape. If I were to go into the studio and invent (or conceive) a landscape, it would be the product of many fluid sources—art history, literature, travel, vision, memory, dream and the myriad of other things I get immersed in—that tints or accents my perception and becomes the suffused projection of my mental picture.

Does this happen for McCormick? I think it does. He speaks of his landscapes as the projection of inner ideas, becoming a view of the self, that are influenced by his surroundings and places where he had lived. McCormick's paintings have the strongest appeal to those of us who tend to carry these thoughts and views of the self, framed in the visual forms and language of landscape. In his book *Landscape and Memory*, author Simon Schama explores, in a series of vivid historical essays, how deeply embedded are the concepts of landscape into racial or national consciousness. Naturally, we are capable as individuals of forming a consciousness that places landscape as a central

motif—even if we are cut off from the natural world. An artist's work is sometimes described as being in the state of "becoming," as a way of characterizing its conception and existence, or perhaps its potential for creating new meaning and experience for the viewer. Each viewer reactivates the state of becoming in McCormick's landscapes, for they are intended to offer experience through emotional resonance. Like the nineteenth-century Barbizon painters of the farms and fields of the Ile de France, or even Whistler's more urban-oriented views of the environment, these paintings are a reflection of the mood that they also create.

When I recently viewed an exhibit of McCormick's newest paintings, I found myself wanting to sit still and silent among them, to allow myself to become suffused by the dusky light, shimmering contours and placid mood generated by the ensemble. I had at first sought to look at them individually, to scrutinize each with a more focused gaze. That process yielded certain information—the blended brushwork and layered pigment, nuances of color and tonality, the dissolution of contours and an absence of minute details. I wanted to regard each scene or view as the extension of a particular place or region, as I could recognize the salient features of the semi-arid, central California coastal landscape that I have visited on occasion. But in order to gain perspective, and explore depth and continuity, I had to step back and stay outside of the work for a moment. I am of the opinion that a successful and satisfying exhibition must be esthetically coherent and more than the sum of its individual elements. In this way I began to feel a connection to the art, to the artist's intentions, to my own feelings and responses and thoughts. It was tranquil, and even refreshing, even though the context I had just come from was the hectic hubbub of midday in a dense urban setting. Before me in the gallery was the slow passage of time, the infinite cycle of light, and silence.

In recent paintings, McCormick has begun to incorporate solid yet empty fields of color as an interlude to the landscape view. Sometimes it is a panel or segment at the base of each composition. In other works, it is a monotone field surrounding a smaller painting mounted in front of it. Some might look at these fields and say there's nothing there. There really isn't, and that's the point. It is the eloquence of silence and emptiness that one seeks in these fields, rather than the absence of what one sees (or doesn't see) there. Sometimes a thing is best apprehended by not apprehending it directly. For me, much can be gathered from the periphery of vision that establishes and reinforces the ambience of a particular experience, whether it is looking at art, looking at a panoramic view of nature, or even recounting the disjointed sequence of events in a dream.

McCormick's landscape paintings take a Platonic view of nature, that order and structure governs nature and its forms and so too should his conception of landscape painting. His compositional arrangements are harmonious, rigorous and contained. The sense of space is orderly, progressional and encompasses the minute and the infinite. The empty fields previously referred to are a product of McCormick's approach to compositional arrangement and order. In addition to establishing silence, the flat fields articulate the formal properties of surface, flatness and mark making that are components of the painting's conception.

The artist is deliberate in his articulation of the underlying geometry of each shape, so that it is not too overt nor too diminished. In subtle ways, he has begun to explore geometrical configurations as a counterpoint to the "natural" landscape by describing it onto the surface of the painting field. It is a way to bring to the forefront the formal considerations of painting, a major component of the painting's conception.

When all is done, John McCormick's paintings are the essence of artistic conception. Internally motivated, carefully thought out, well crafted and sensitively presented, he has considered all that is essential to consider when making art. By focusing on landscape as his central motif and subject, he connects with the world of nature and with our own private worlds of memory, experience and place.

Ron Glowen is an independent art critic based in Seattle. He is a contributing editor and columnist for Artweek Magazine and the visual arts reviewer for The Herald newspaper in Everett, Washington. Glowen has written for numerous art periodicals including Art in America and American Craft, and has published exhibition catalog essays for many art institutions including the Tacoma Art Museum, San Francisco Museum of Modern Art, and the Tucson Art Museum.

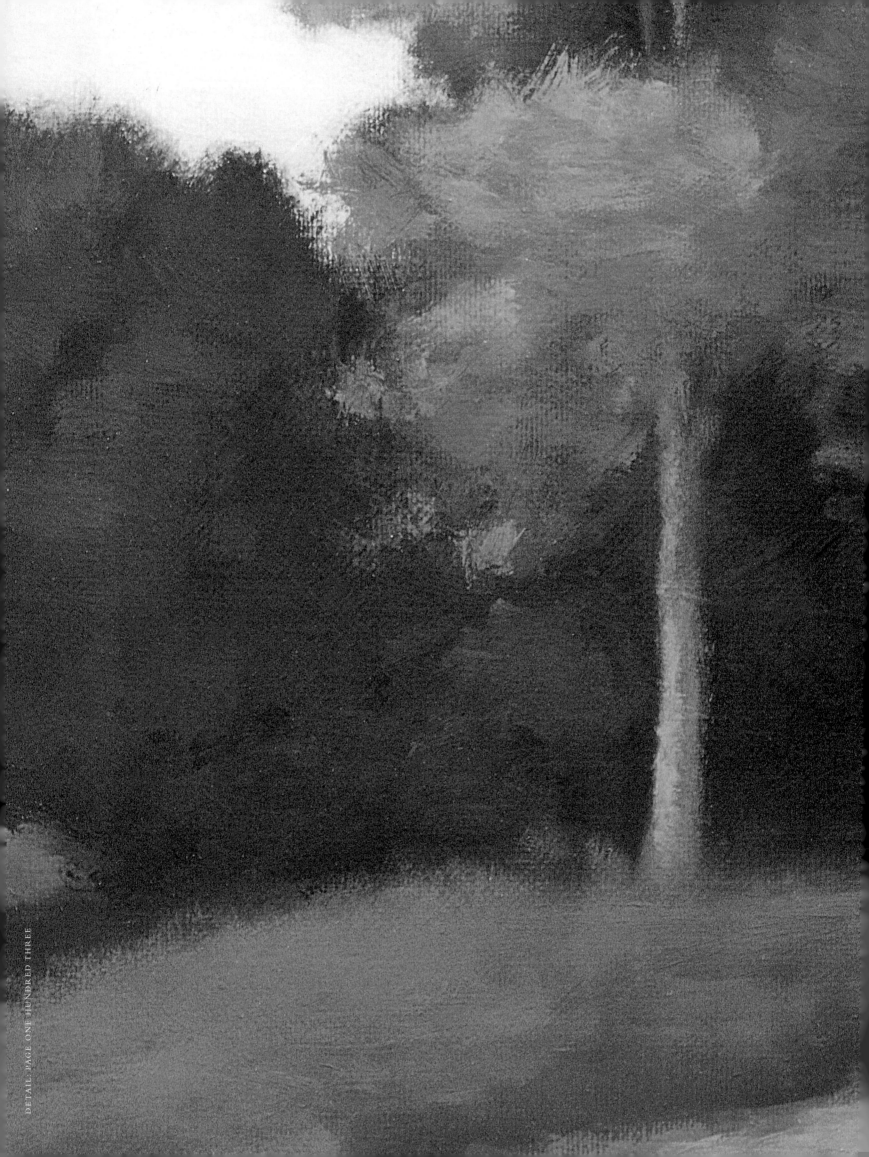

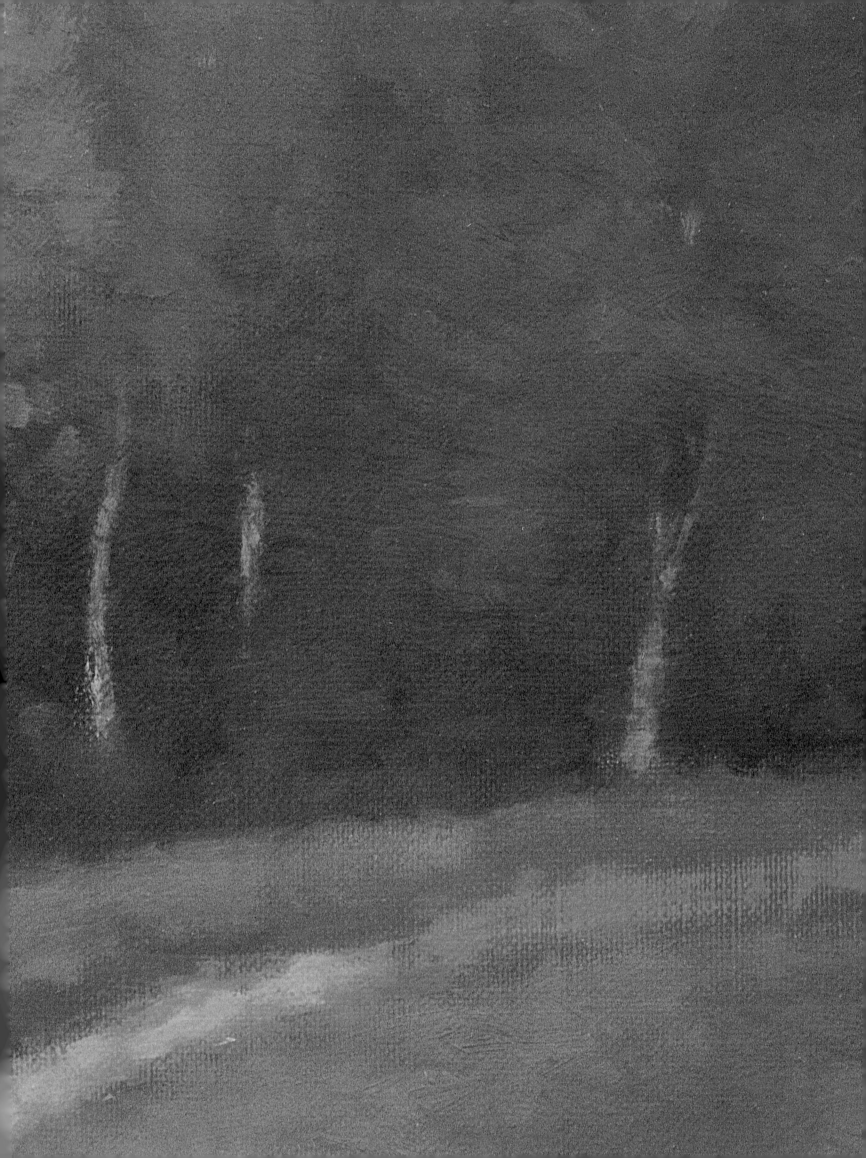

DRAKES BEACH

OIL ON PANEL | 10 INCHES x 8 INCHES | 1992

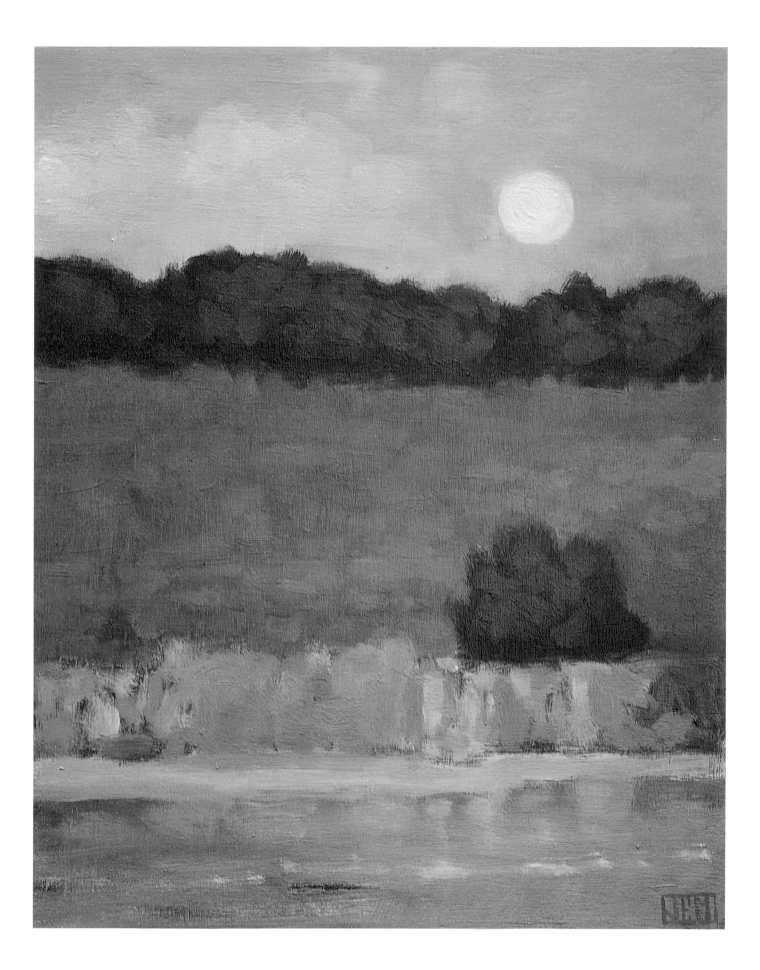

THIRTEEN

TODAY OLEMA NUMBER TWO

OIL ON CANVAS | 30 INCHES x 22 INCHES | 1993

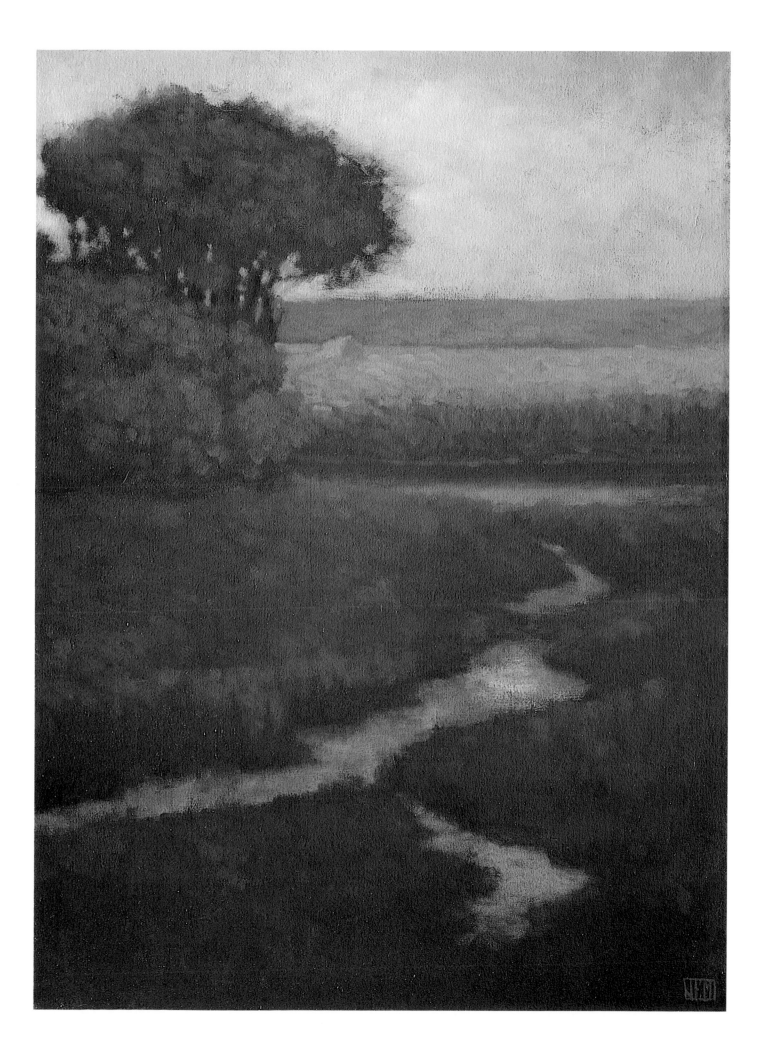

INDIAN SUMMER (STUDY)
OIL ON CANVAS | 24 INCHES x 18 INCHES | 1994

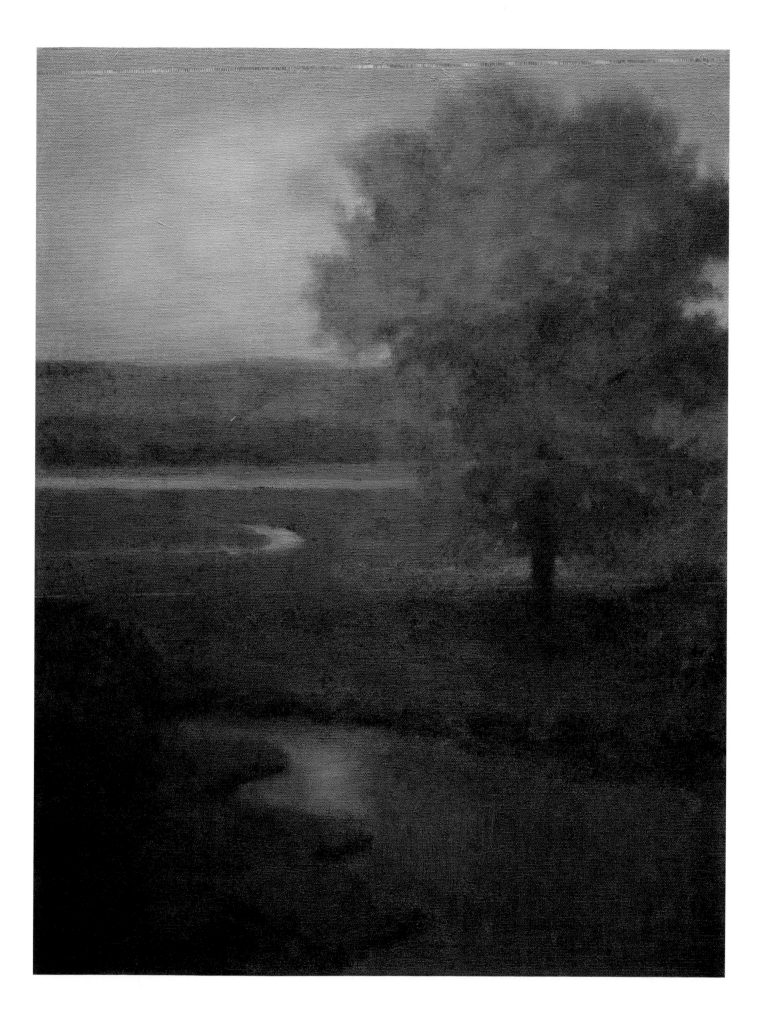

INDIAN SUMMER NUMBER TWO

OIL ON CANVAS | 36 INCHES x 36 INCHES | 1994

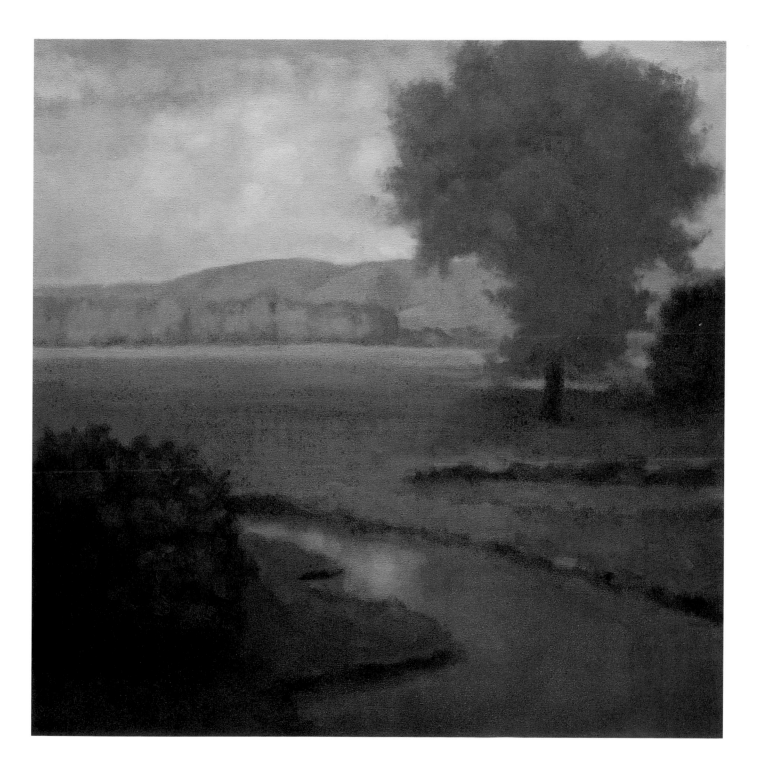

POMO

OIL ON CANVAS | 36 INCHES x 36 INCHES | 1995

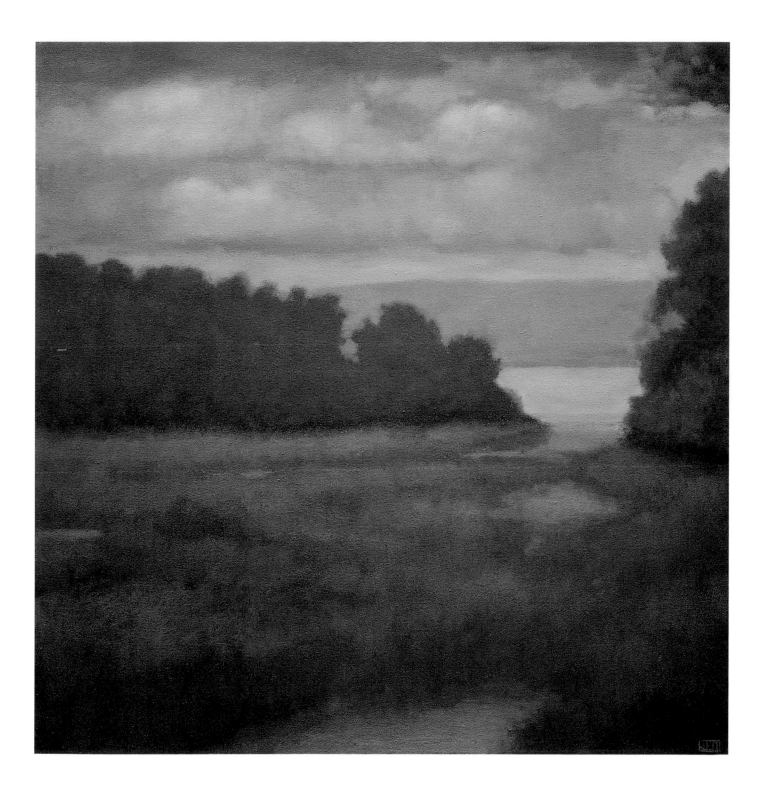

INVERNESS MARSH (TOMALES BAY)
OIL ON CANVAS I 48 INCHES x 36 INCHES I 1998

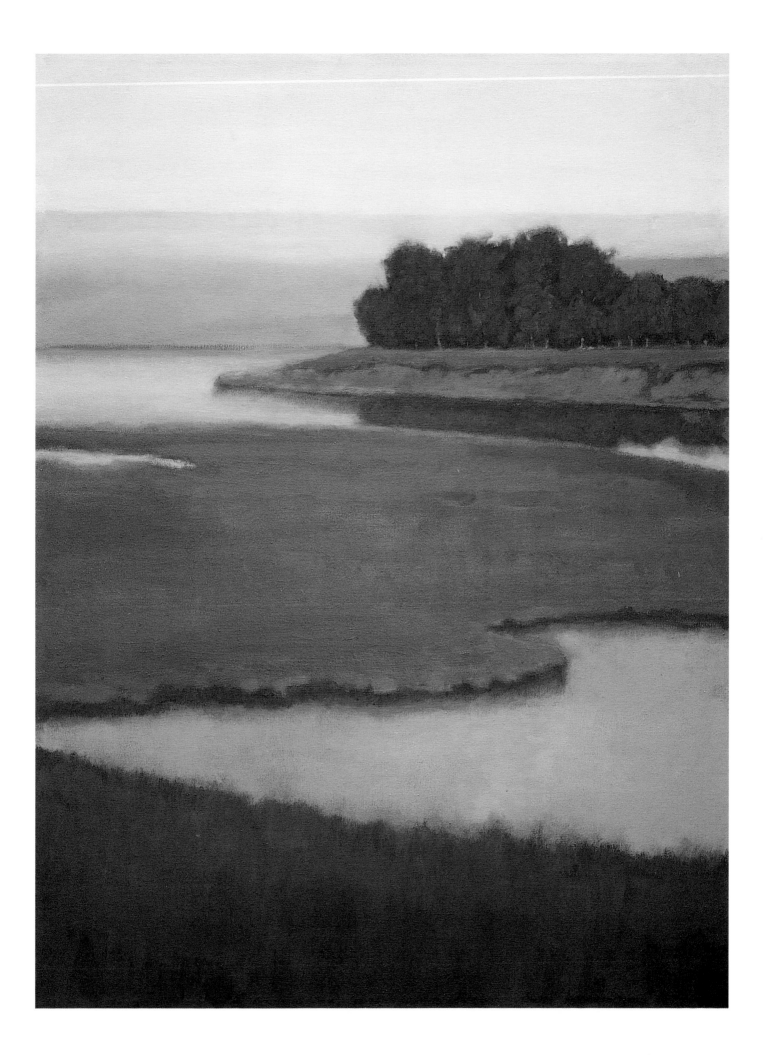

DELTA NUMBER TWO

OIL ON CANVAS | 60 INCHES x 48 INCHES | 1998

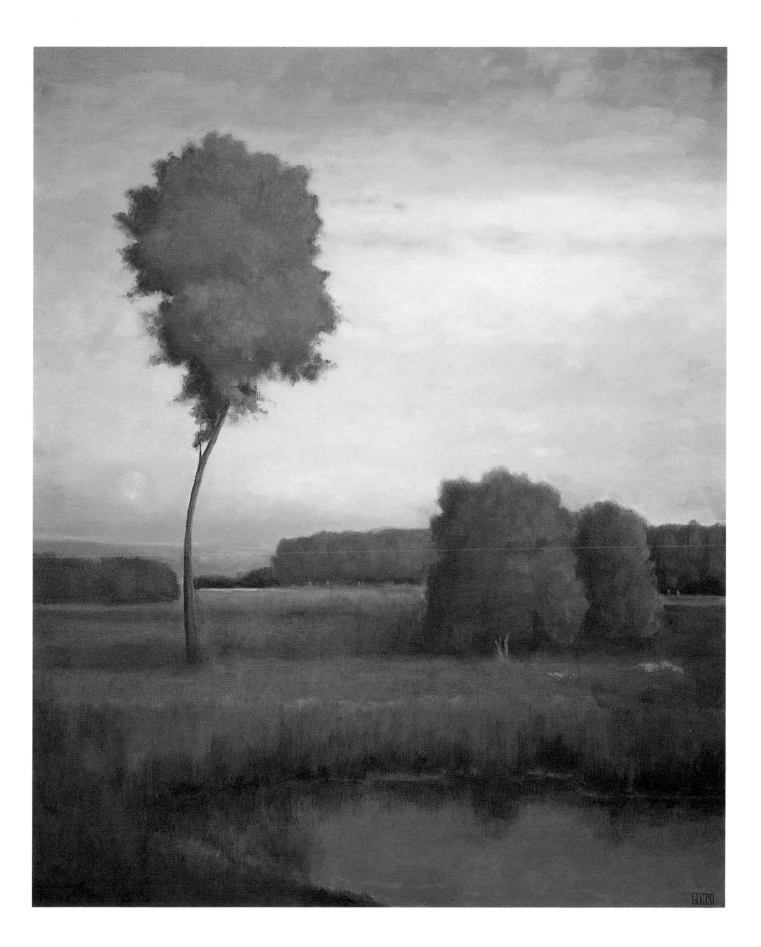

LANDSCAPE (BODEGA BAY)
OIL ON CANVAS | 60 INCHES x 60 INCHES | 1999

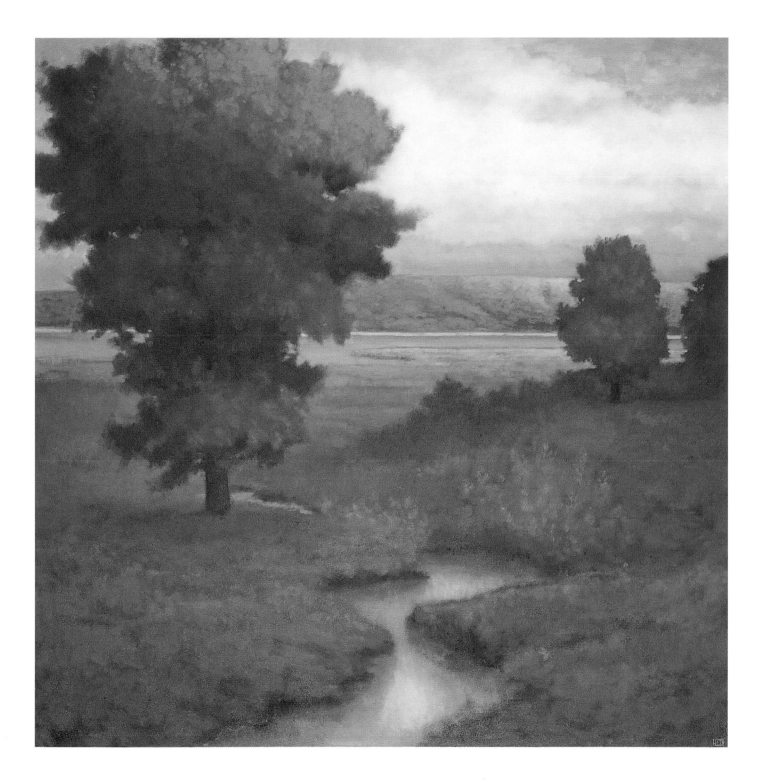

TWENTY-SEVEN

POMO NUMBER THREE
OIL ON CANVAS ı 36 INCHES x 36 INCHES ı 1999

PREVIOUS PAGE: POMO CREEK OIL ON CANVAS ı 36 INCHES x 60 INCHES ı 1999

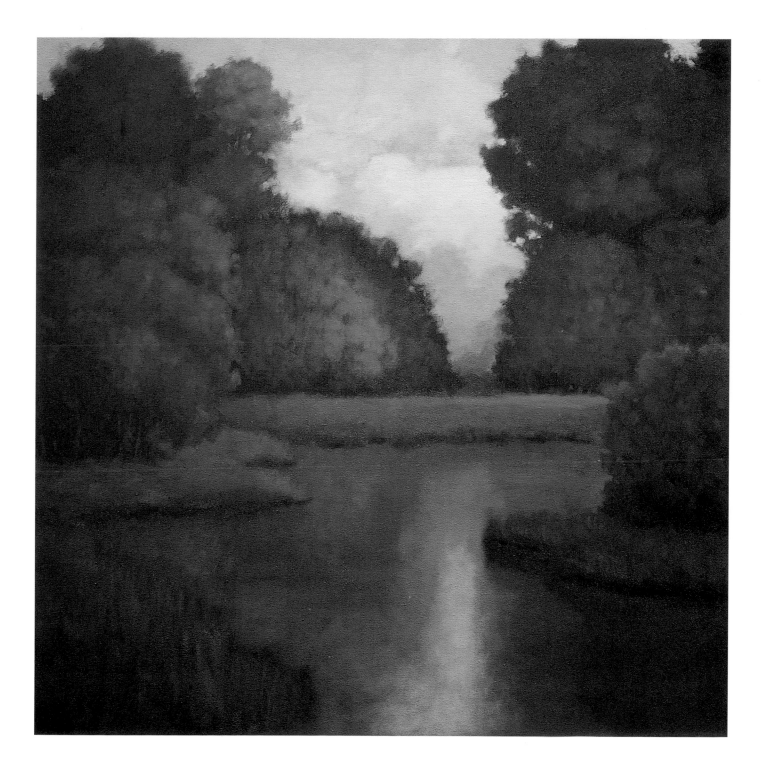

QUIET WATER
OIL ON CANVAS I 36 INCHES x 36 INCHES I 1999

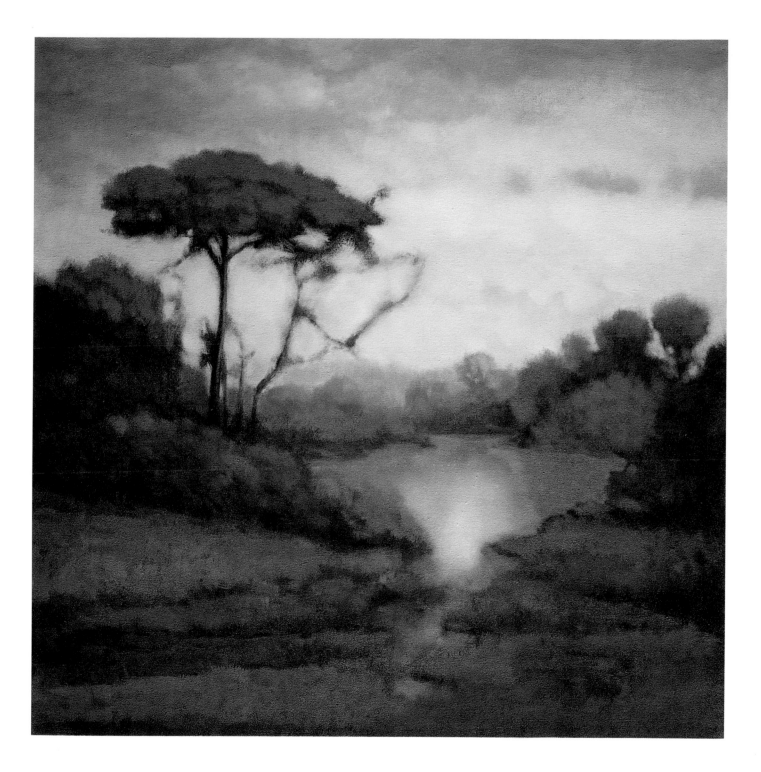

LATE SKY

OIL ON CANVAS | 48 INCHES x 60 INCHES | 1999

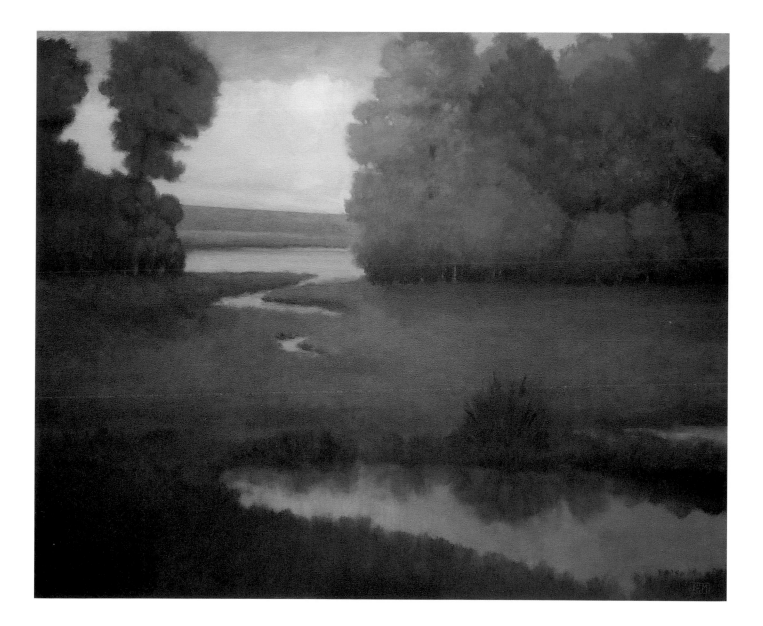

OCTOBER MORNING

OIL ON CANVAS I 60 INCHES x 60 INCHES I 1999

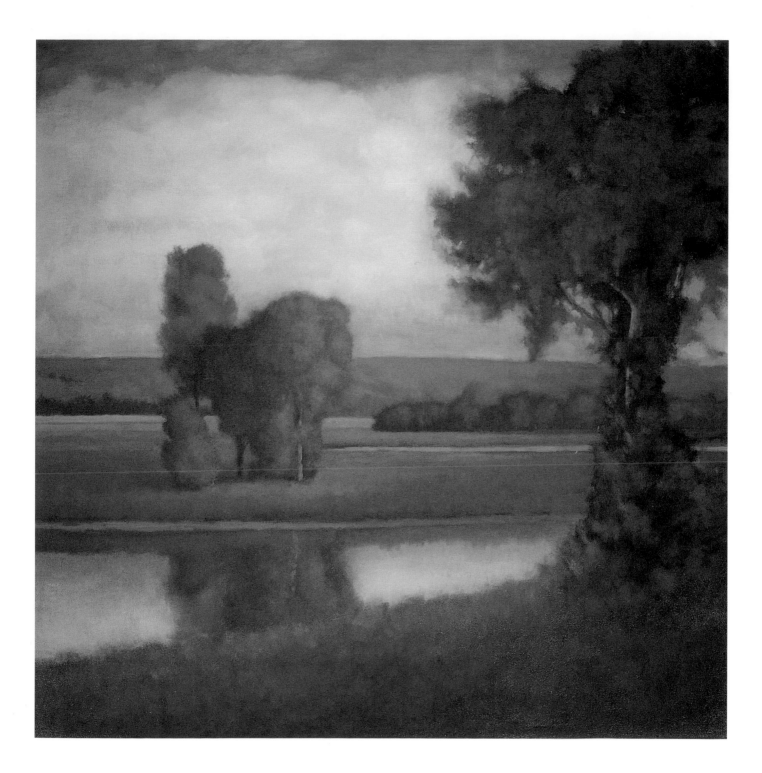

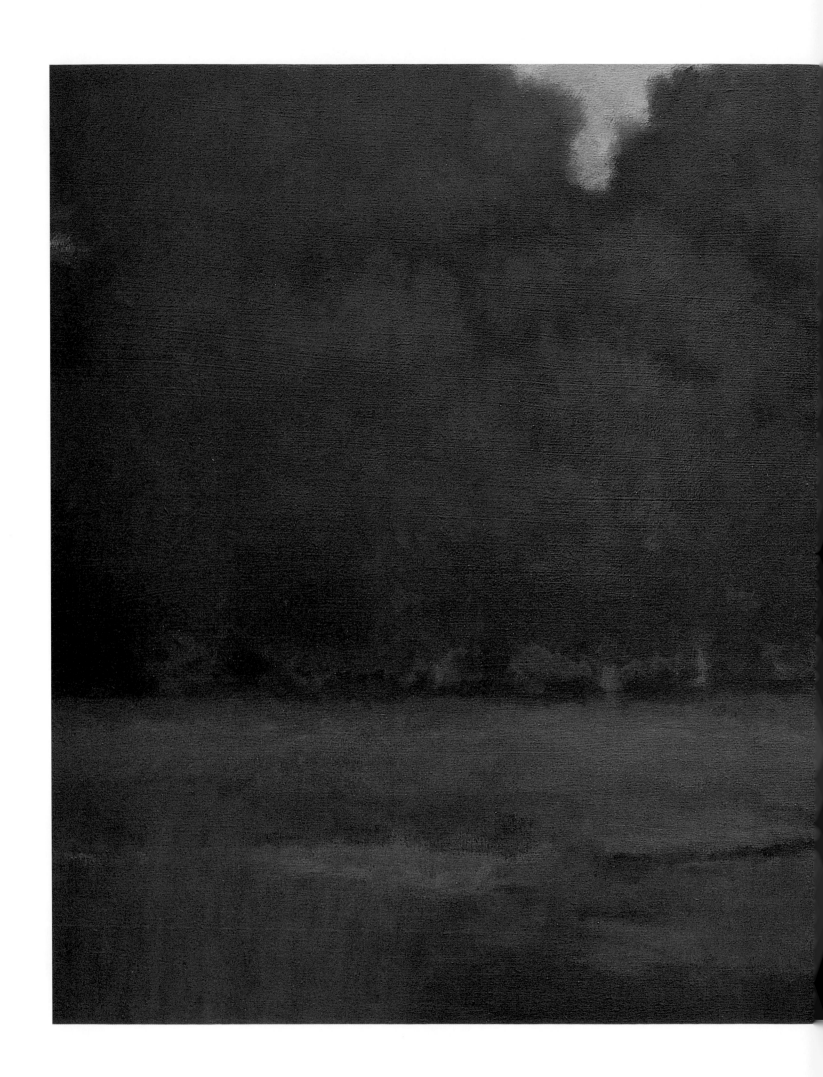

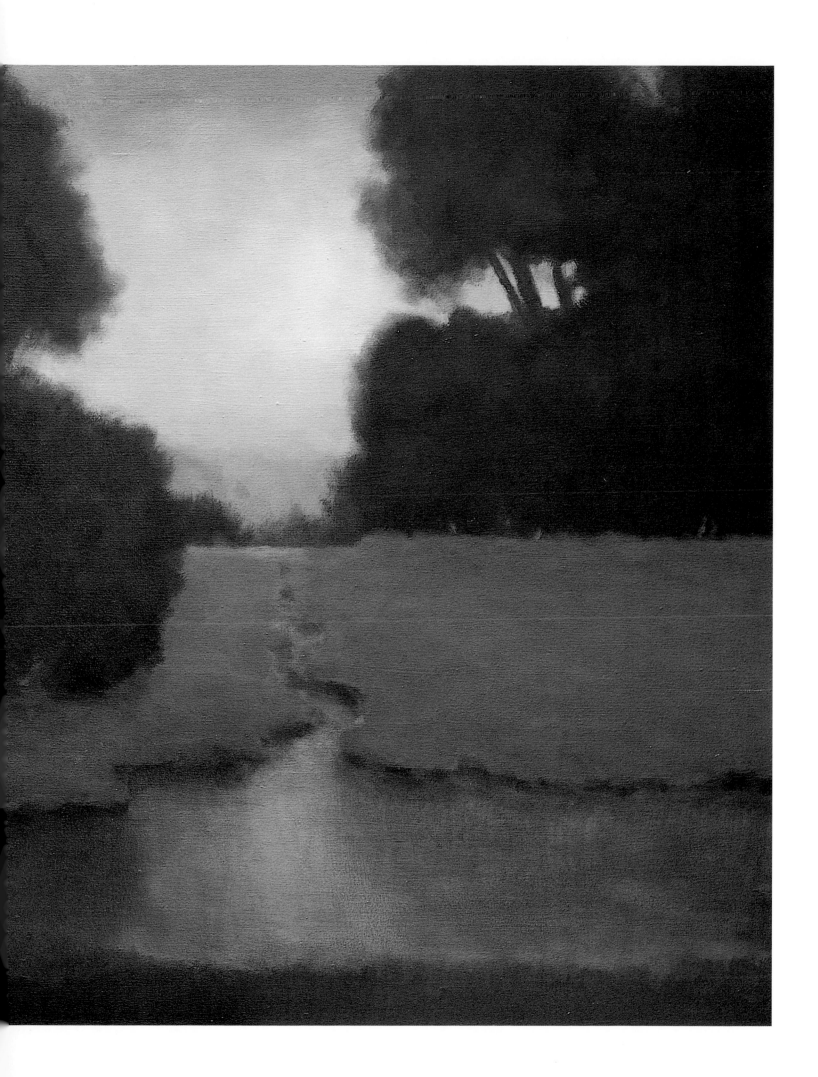

TOCALOMA
OIL ON CANVAS | 60 INCHES X 48 INCHES | 1999

PREVIOUS PAGE: PENUMBRA AT THE EDGE OF THE SILENT WOODS OIL ON CANVAS | 36 INCHES X 60 INCHES | 1999

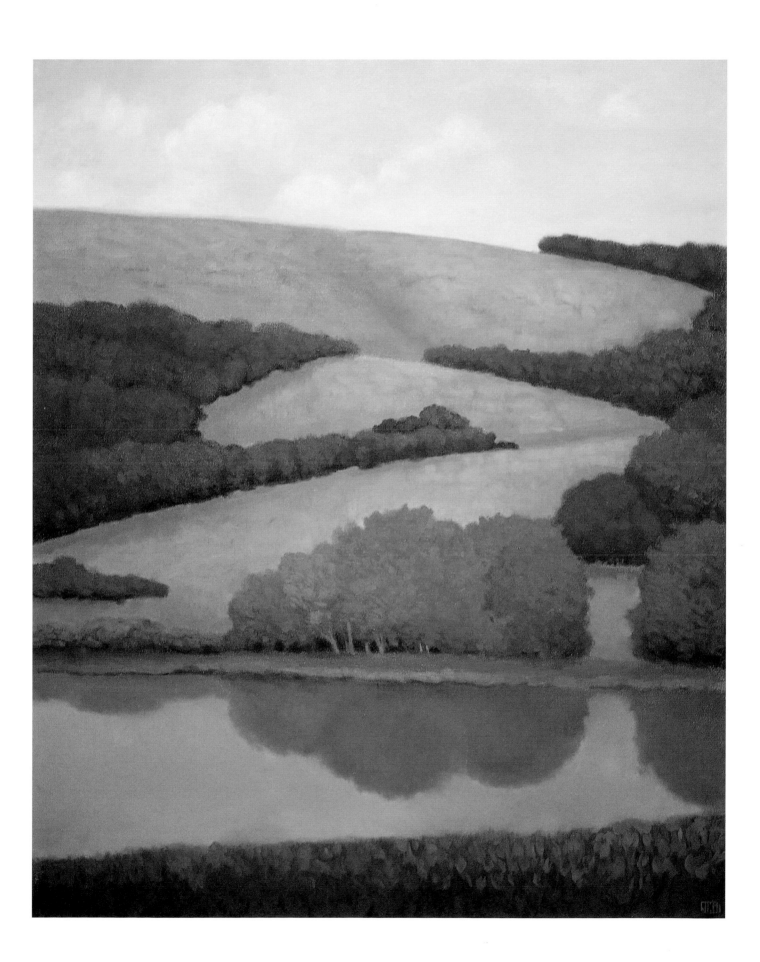

UNDER THE OAKS

OIL ON CANVAS ON PANEL | 48 INCHES x 60 INCHES | 1999

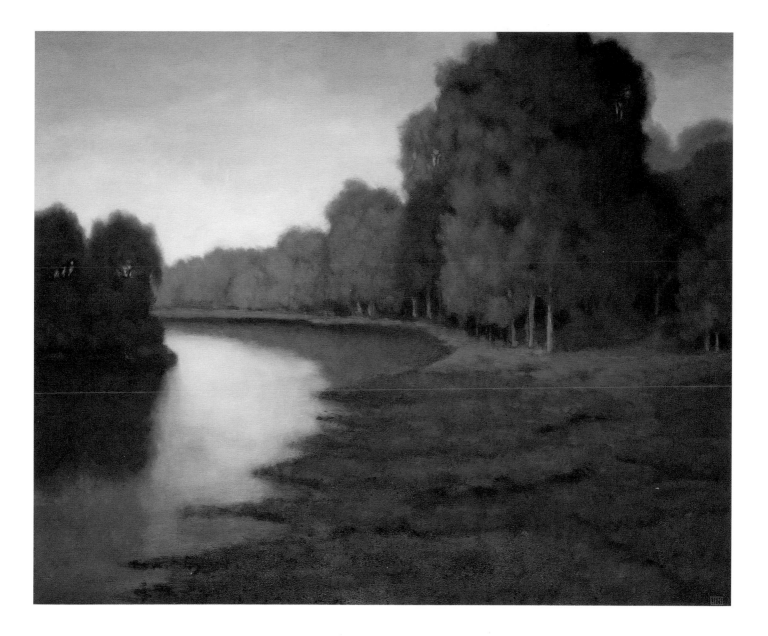

CROSSROADS
OIL ON CANVAS | 36 INCHES x 36 INCHES | 1999

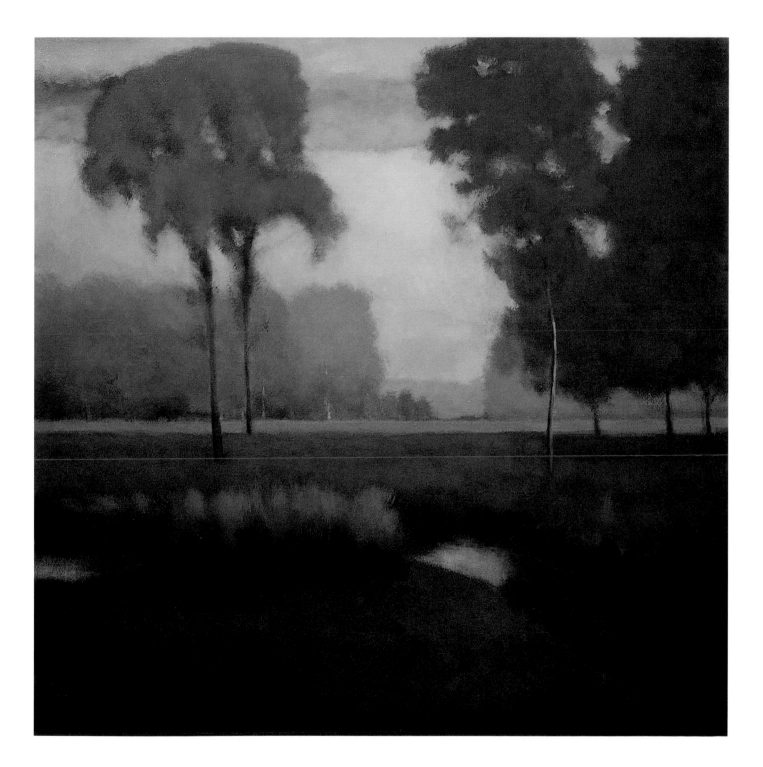

THE FIELD

OIL ON CANVAS | 36 INCHES X 36 INCHES | 1999

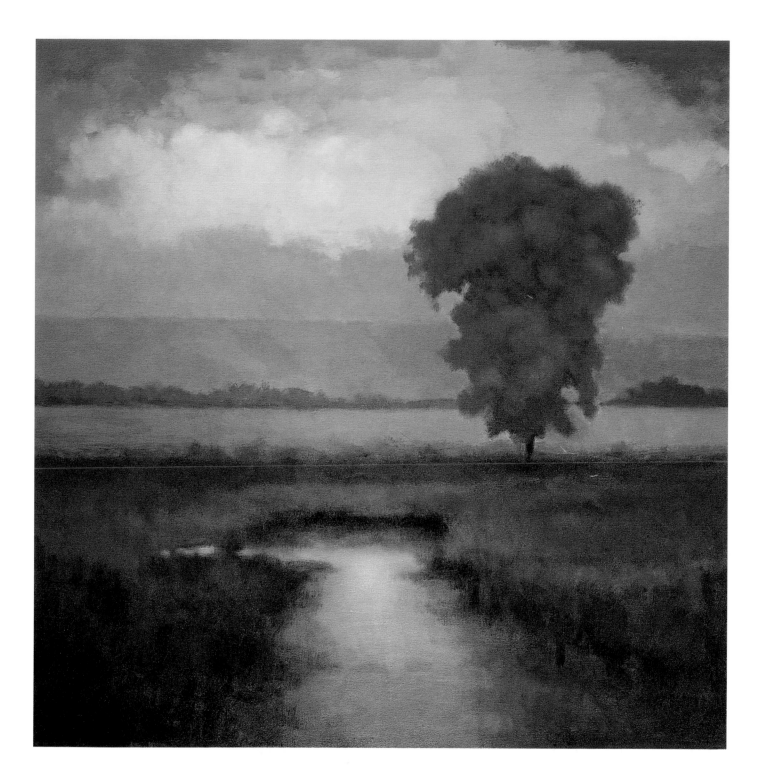

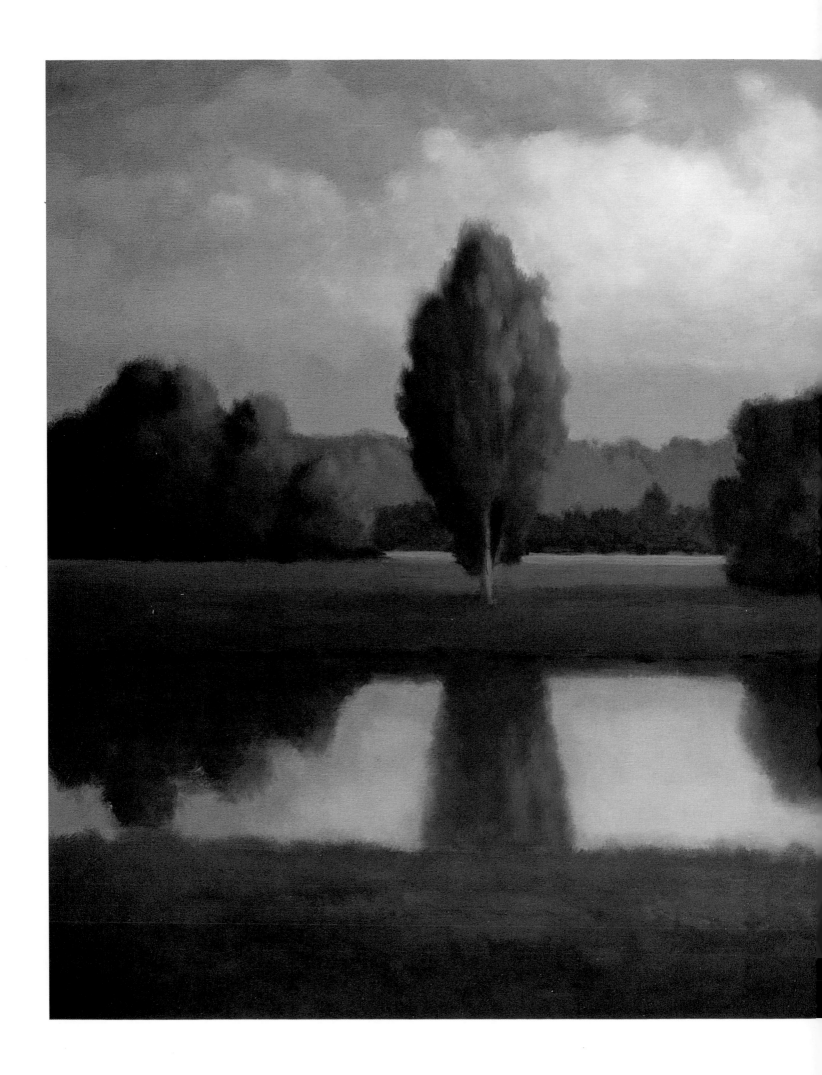

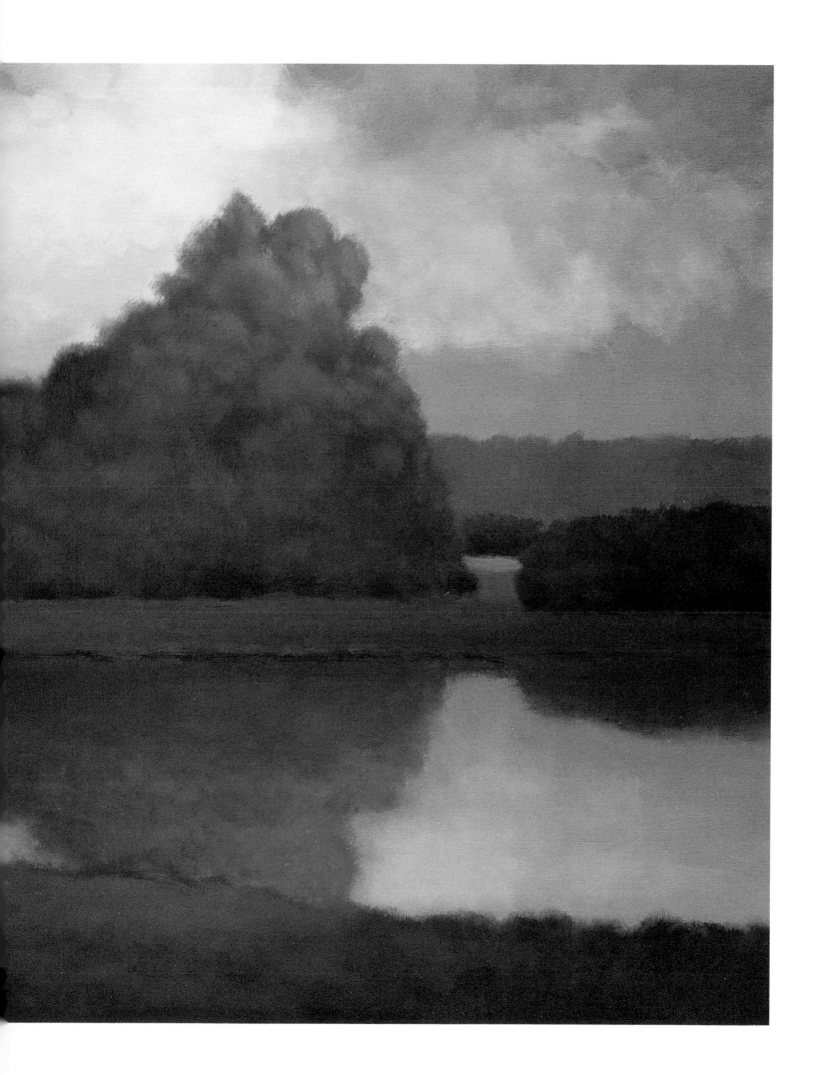

EARTHSMOKE AND RUE

OIL ON LINEN | 36 INCHES x 36 INCHES | 2000

PREVIOUS PAGE: LATE AFTERNOON, RIVER OIL ON LINEN | 36 INCHES x 60 INCHES | 1999

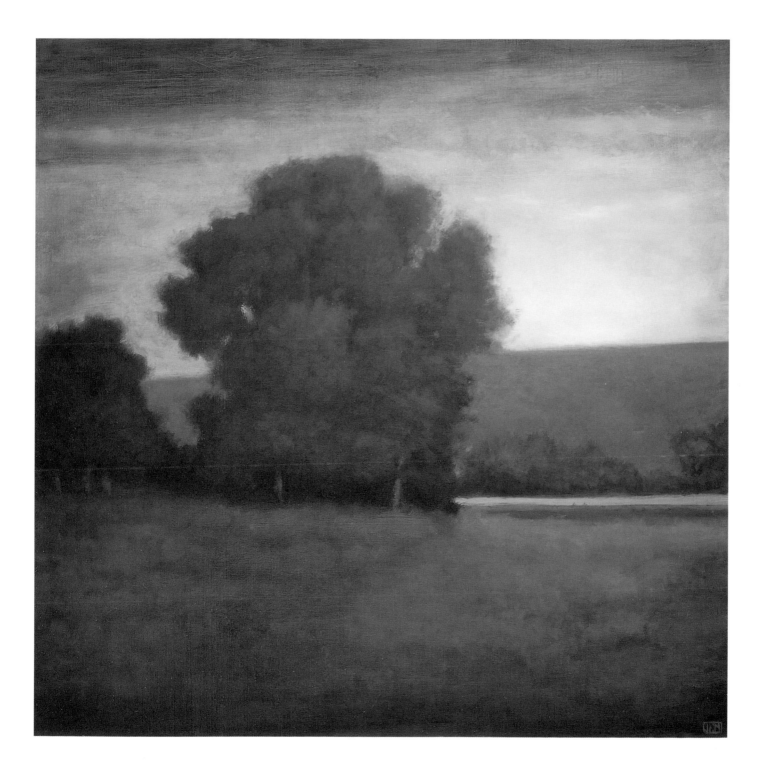

MIWOK NUMBER FOUR
OIL ON CANVAS I 36 INCHES x 36 INCHES I 2000

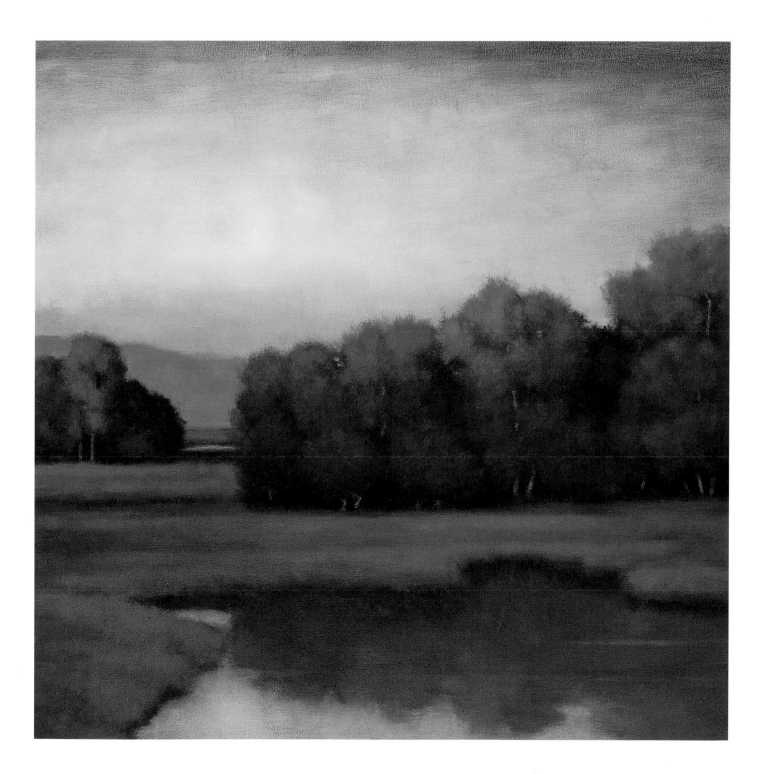

INVERNESS MARSH

OIL ON LINEN | 24 INCHES X 30 INCHES | 2000

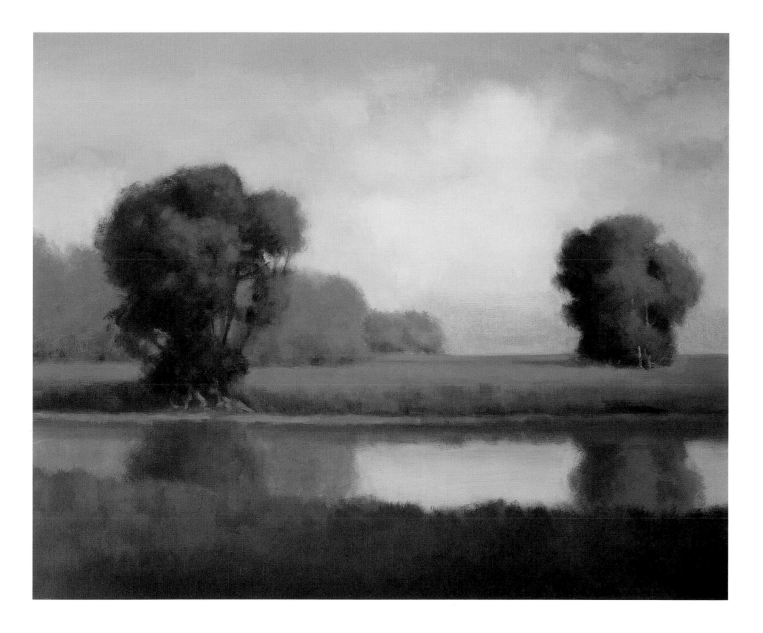

DESIRE LIES DOWN WITH THE DAY

OIL ON LINEN | 48 INCHES x 36 INCHES | 2000

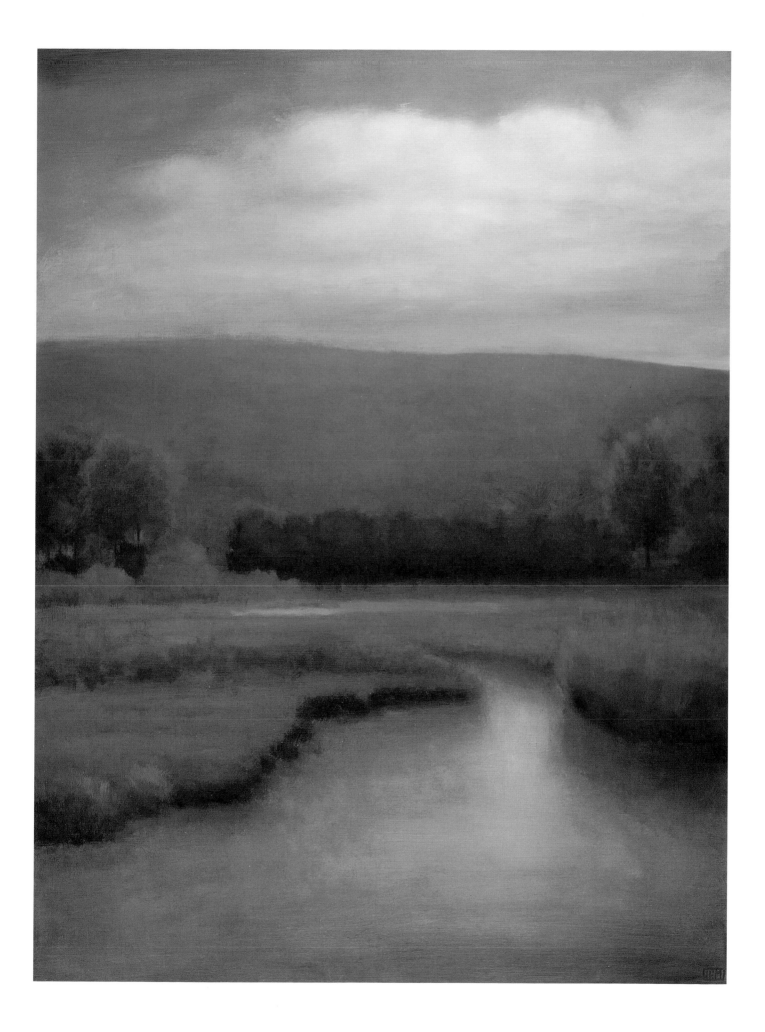

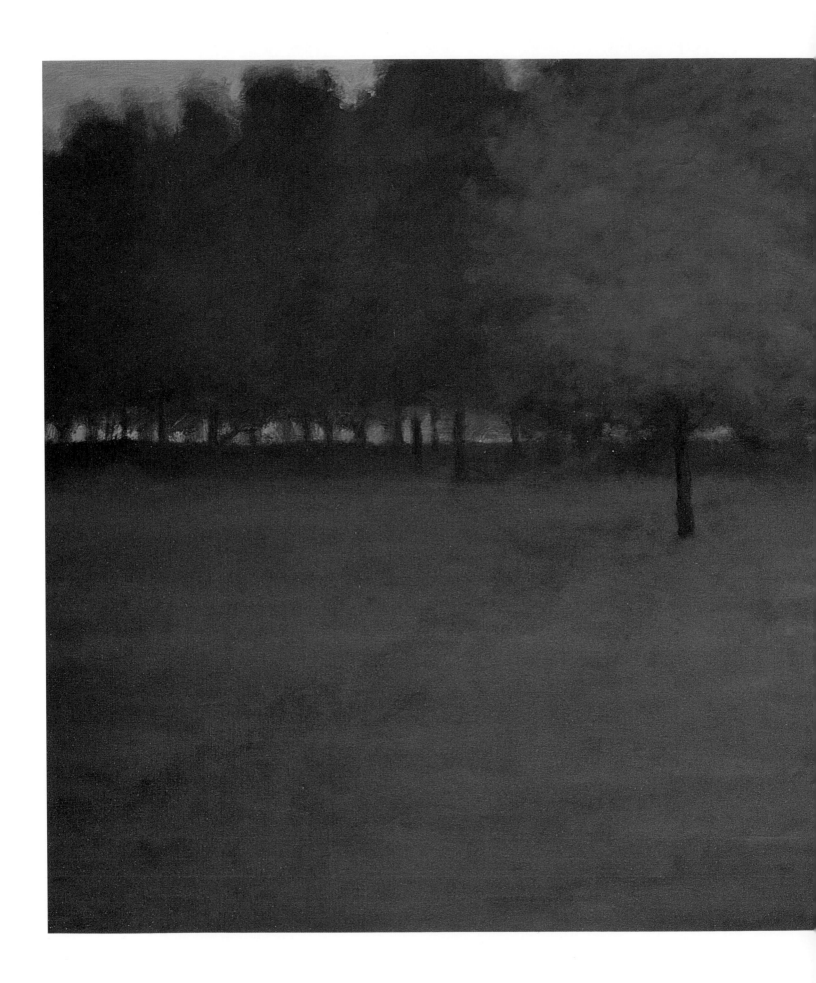

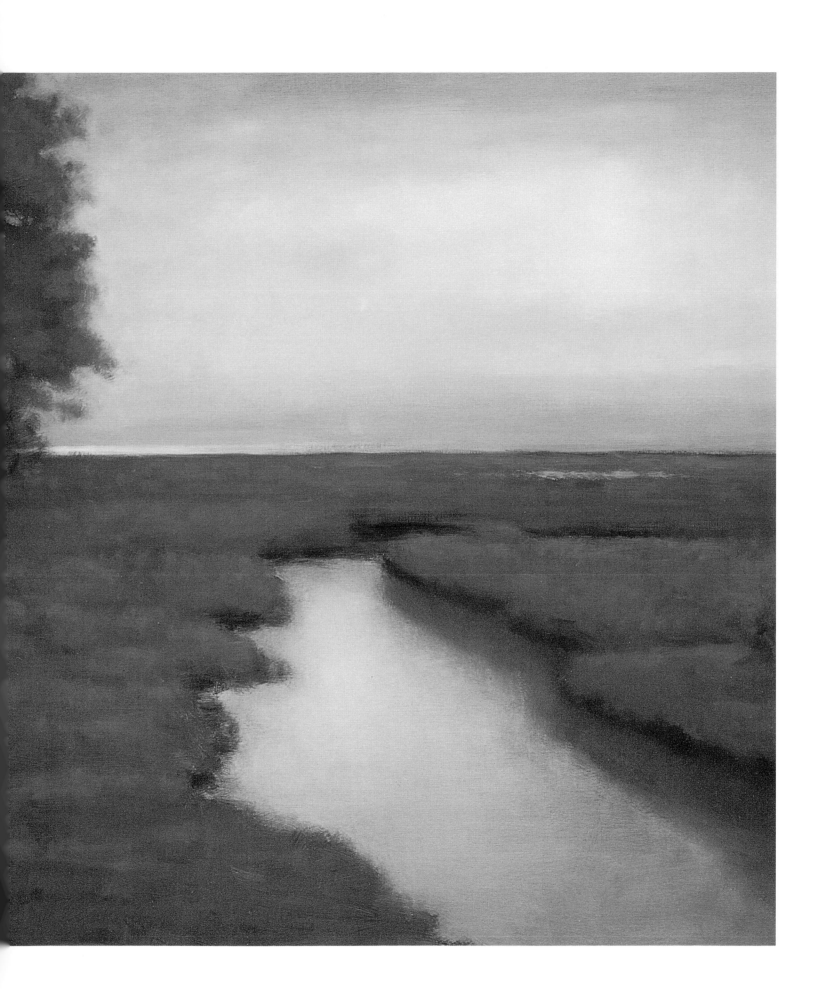

ALONG THE NAVARRO
OIL ON LINEN | 30 INCHES x 24 INCHES | 2000

PREVIOUS PAGE: WHERE WATER COMES TOGETHER WITH OTHER WATER OIL ON LINEN | 36 INCHES x 84 INCHES | 2000

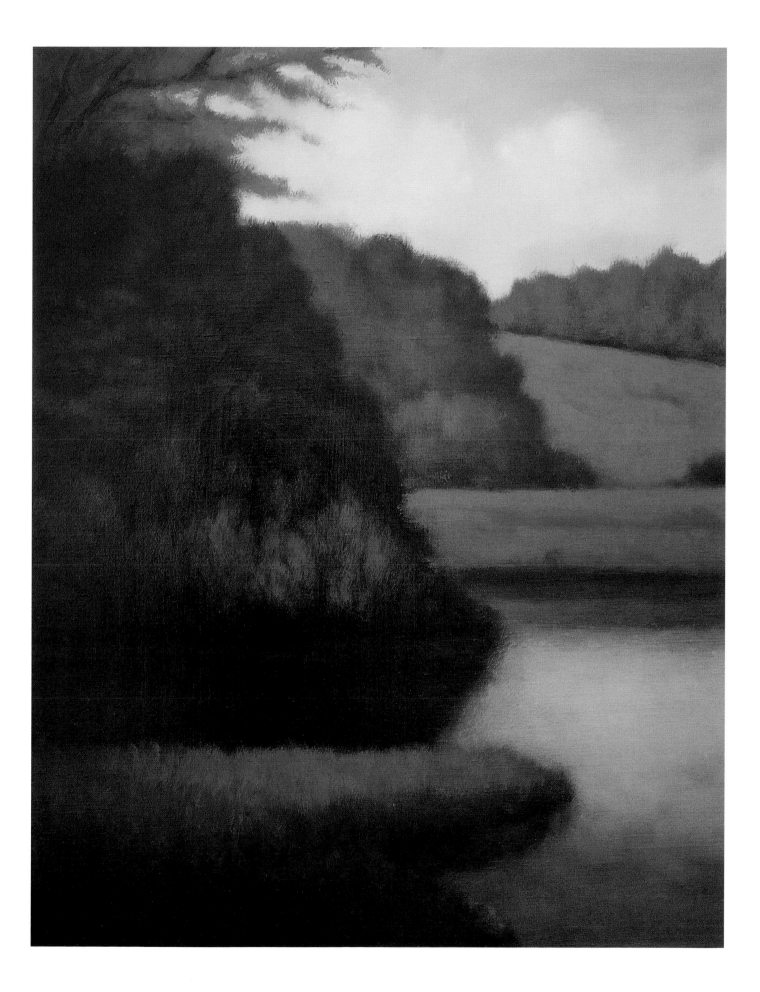

PASSING LIGHT

OIL ON LINEN | 78 INCHES x 60 INCHES | 2000

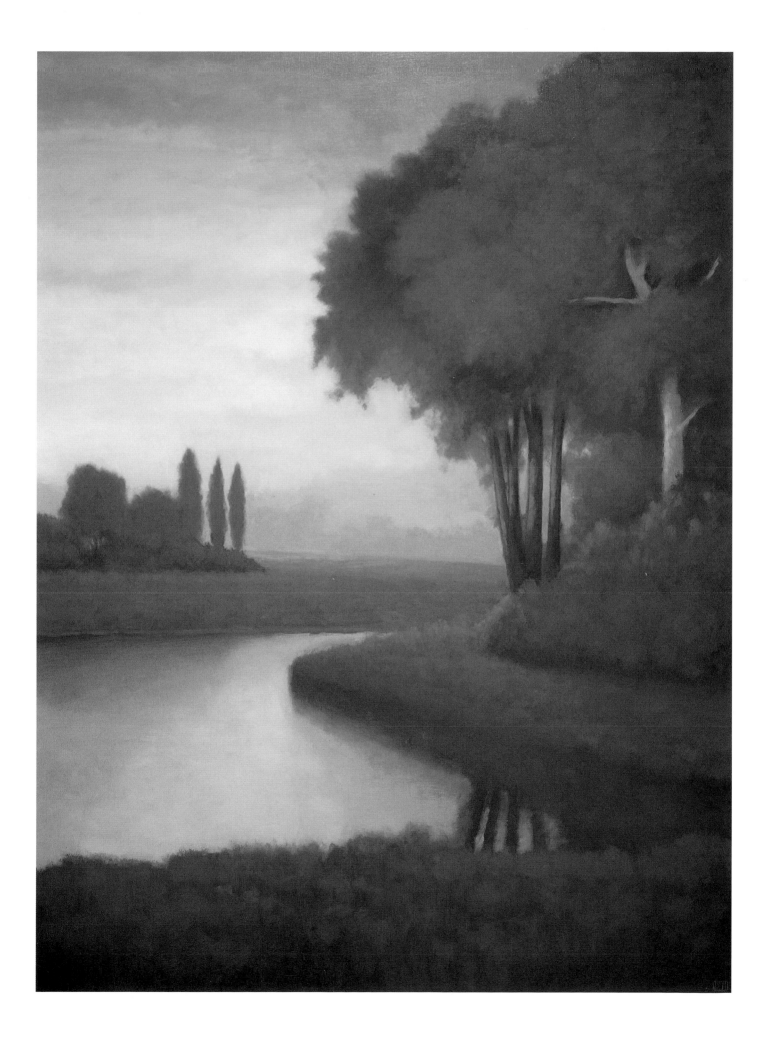

PENUMBRA OVER BOLINAS
OIL ON LINEN | 48 INCHES X 36 INCHES | 2000

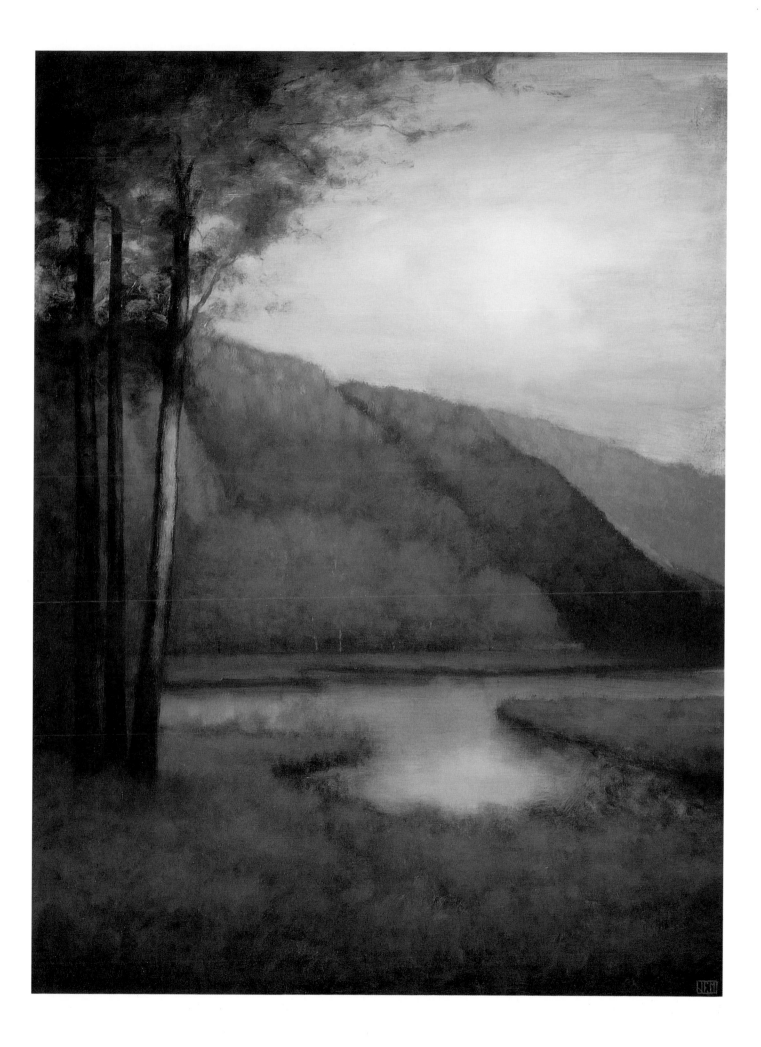

AFTER THE RAIN NUMBER ONE

OIL ON LINEN I 24 INCHES x 30 INCHES I 2000

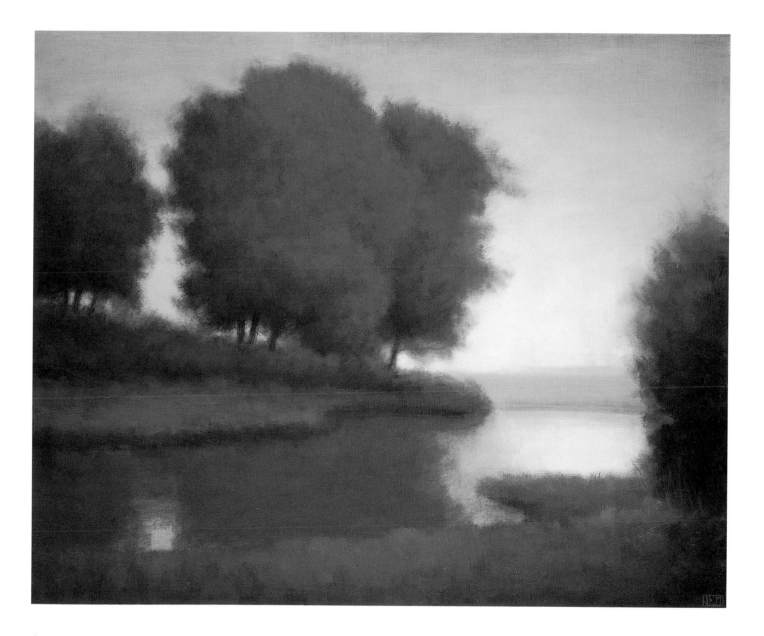

UNTITLED, STUDY ONE
OIL ON PANEL | 8 INCHES X 10 INCHES | 2000

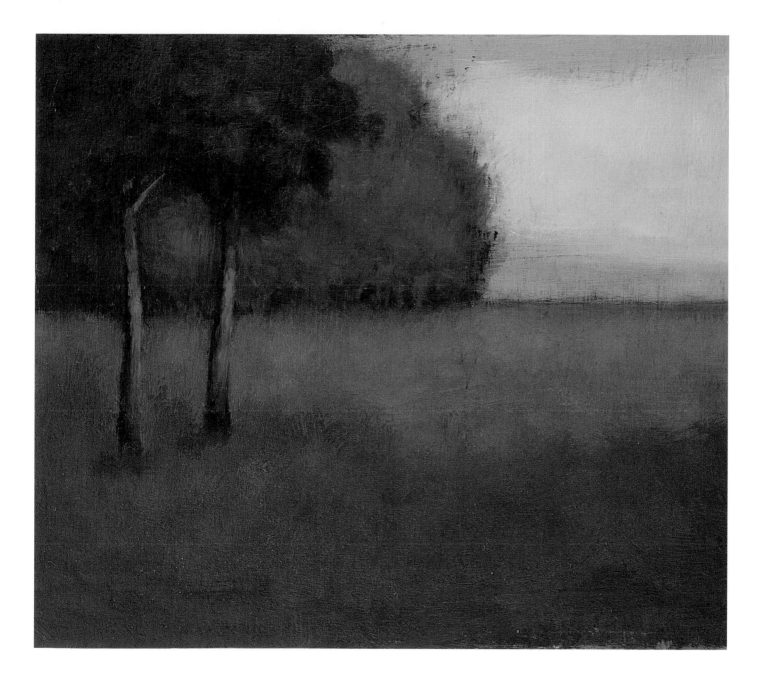

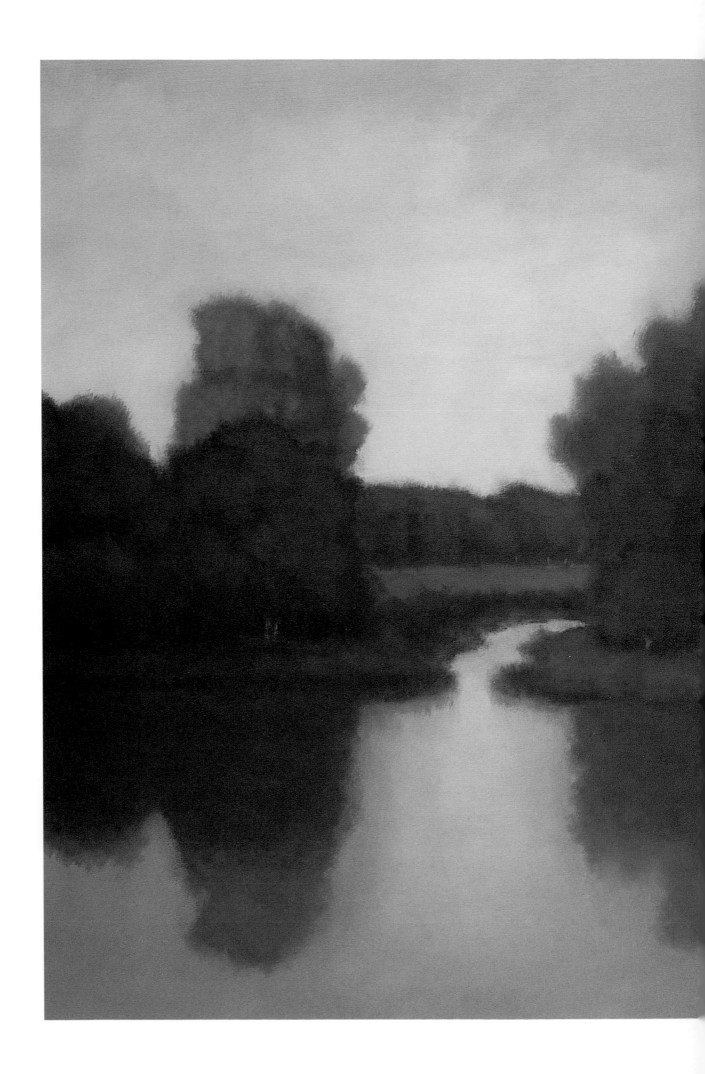

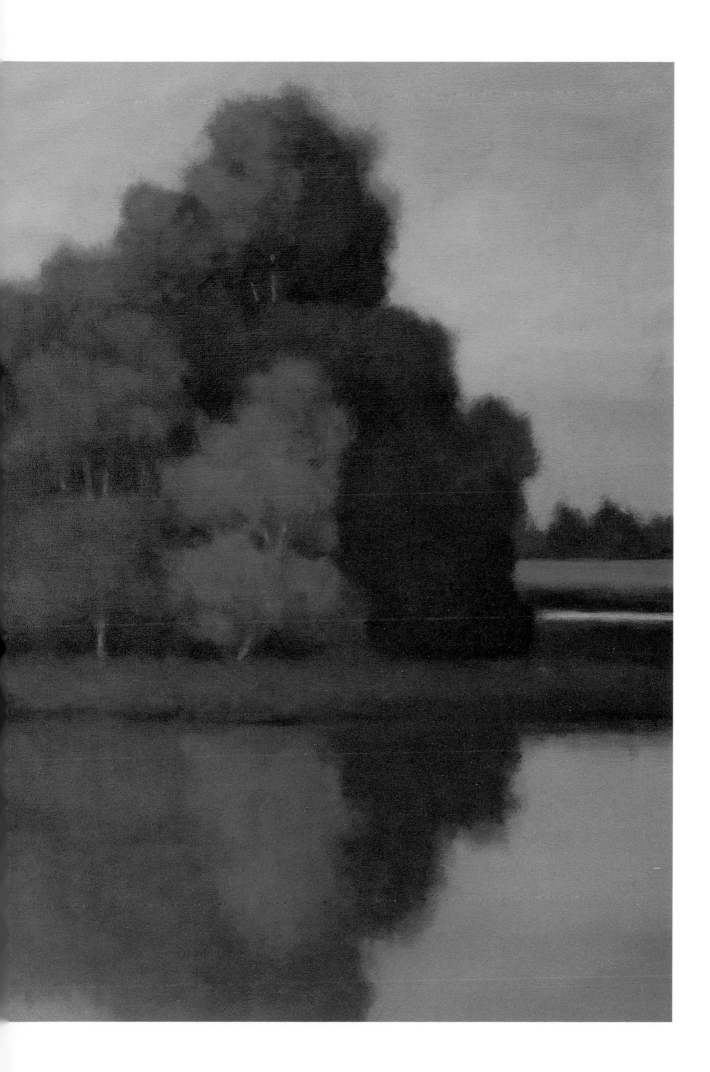

THE QUIET POND
OIL ON LINEN I 48 INCHES X 48 INCHES I 2000

PREVIOUS PAGE: ISLAND, HIGH TIDE OIL ON CANVAS I 36 INCHES X 48 INCHES I 2000

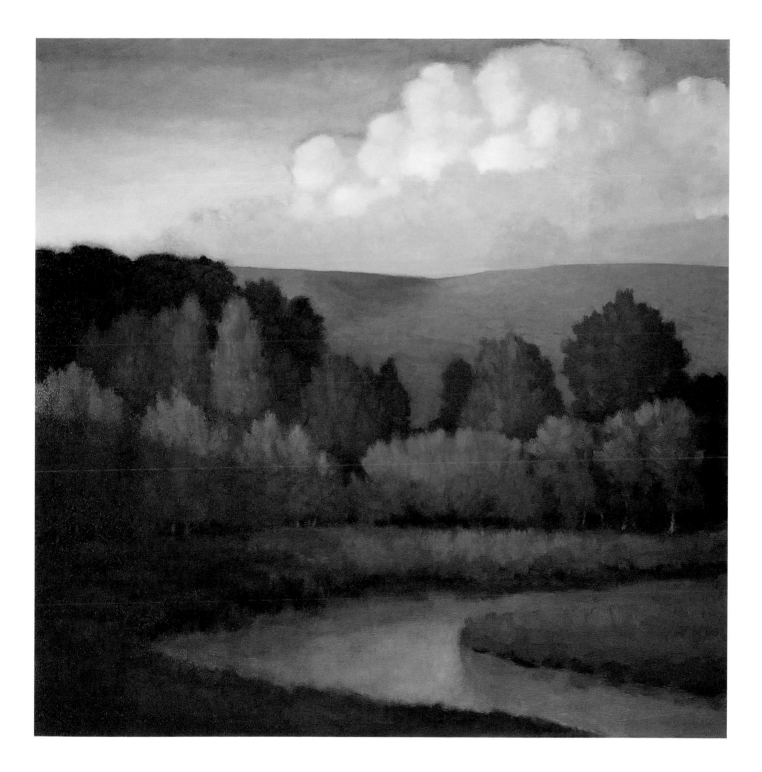

ALBEE CREEK, AUTUMN

OIL ON CANVAS | 30 INCHES X 30 INCHES | 2001

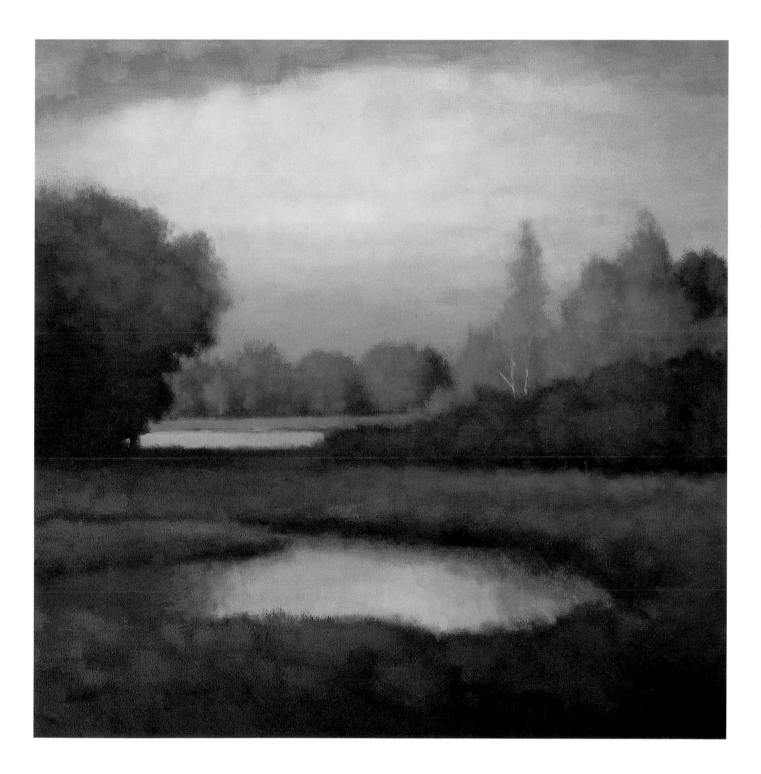

ALONG THE MARSH

OIL ON LINEN | 30 INCHES X 30 INCHES | 2001

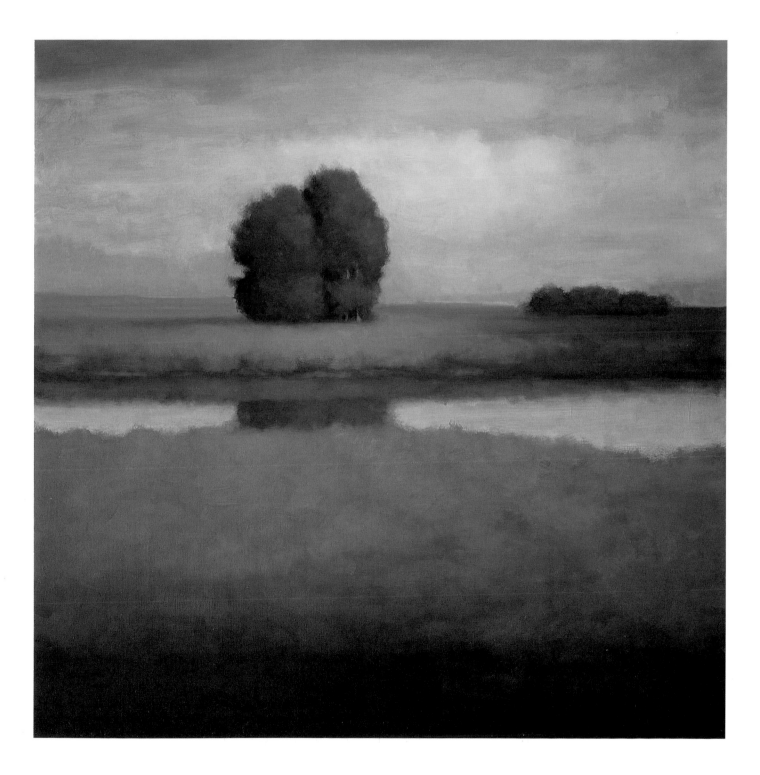

OLEMA SUNSET

OIL ON LINEN | 30 INCHES X 30 INCHES | 2001

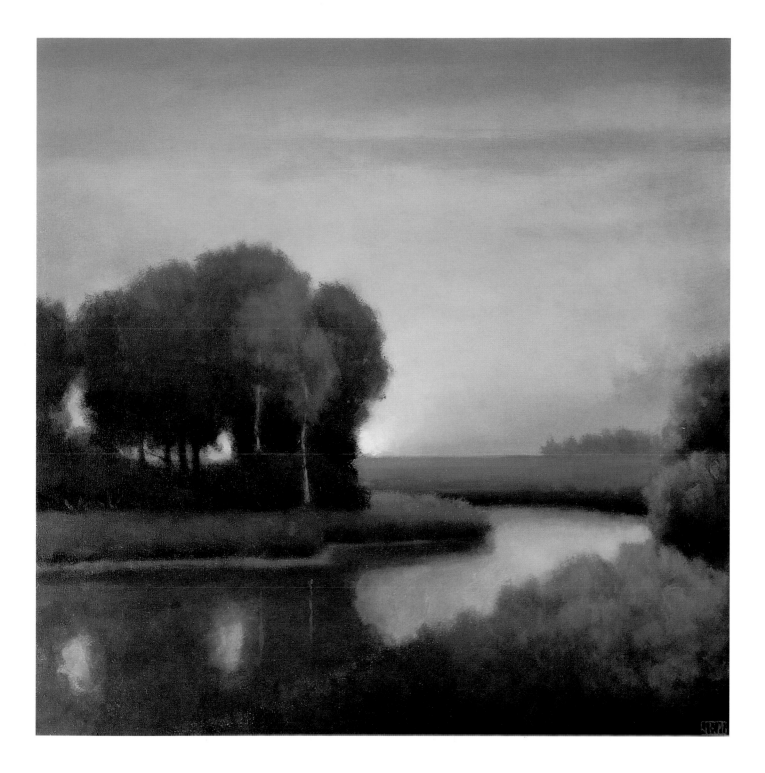

ALBEE CREEK, SUMMER
OIL ON CANVAS | 30 INCHES x 30 INCHES | 2001

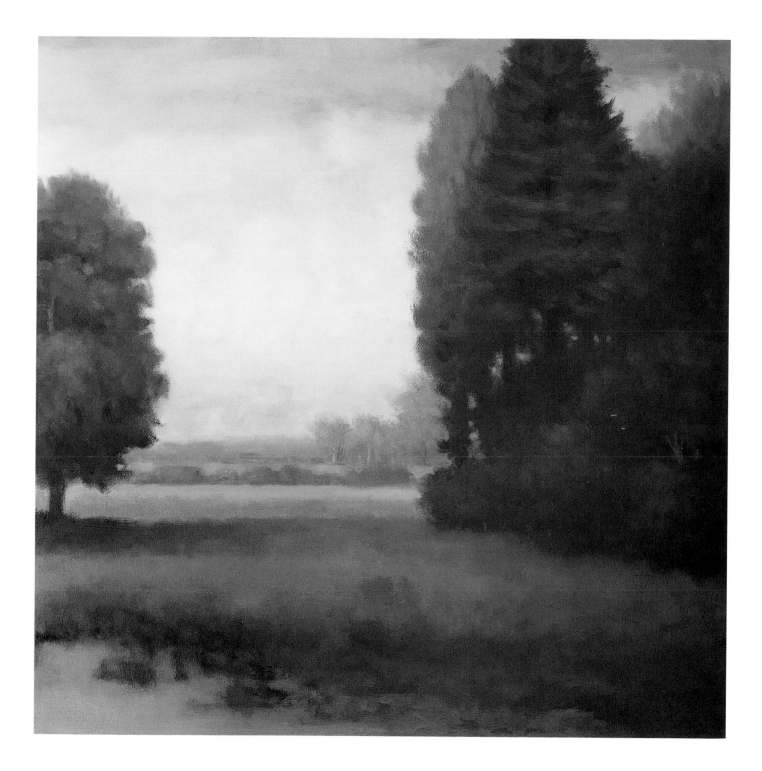

BON TEMPE

OIL ON LINEN | 30 INCHES x 30 INCHES | 2001

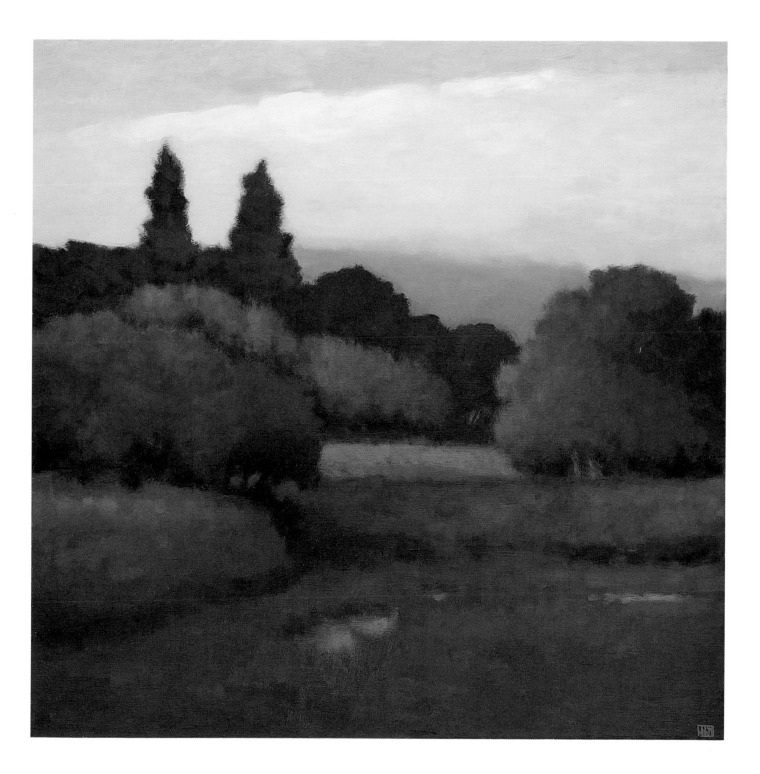

PAPERMILL CREEK

OIL ON LINEN ON PANEL | 24 INCHES x 18 INCHES | 2001

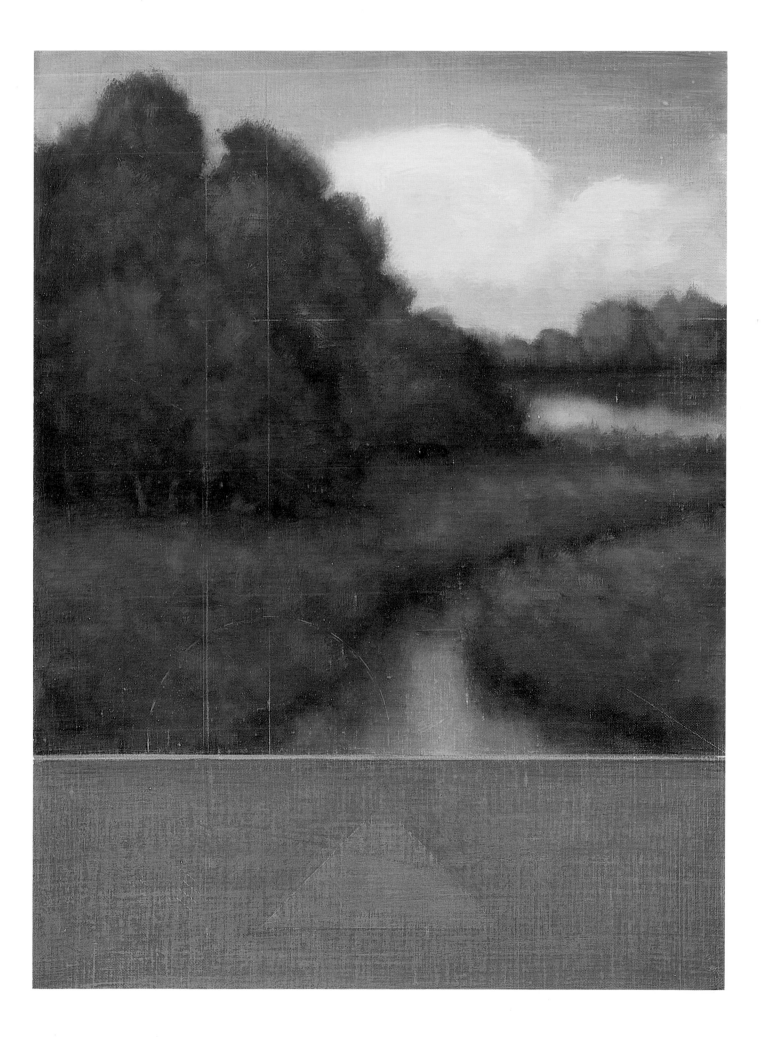

MT VISION

OIL ON LINEN ON PANEL | 24 INCHES x 18 INCHES | 2001

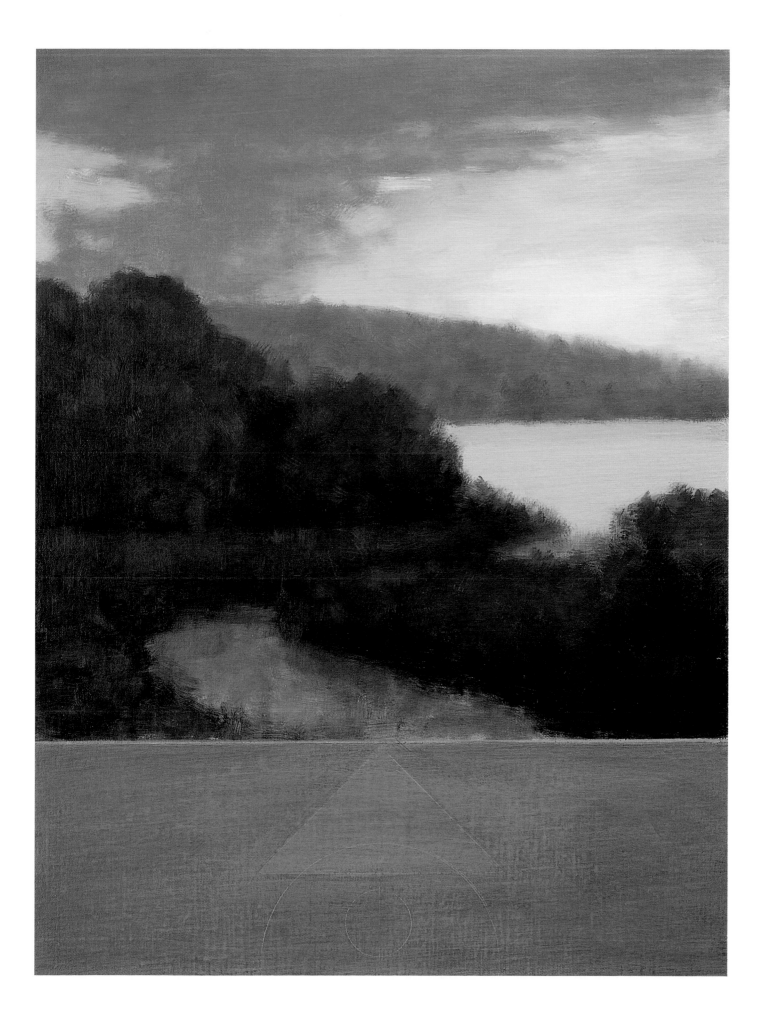

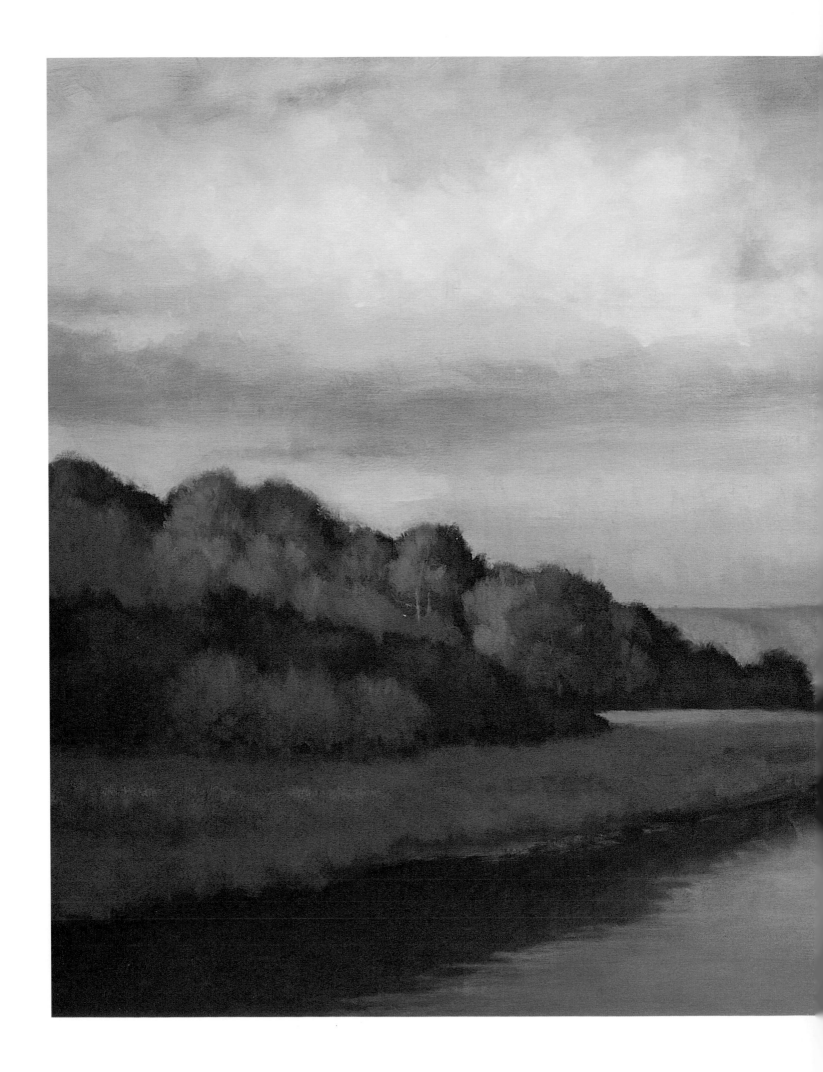

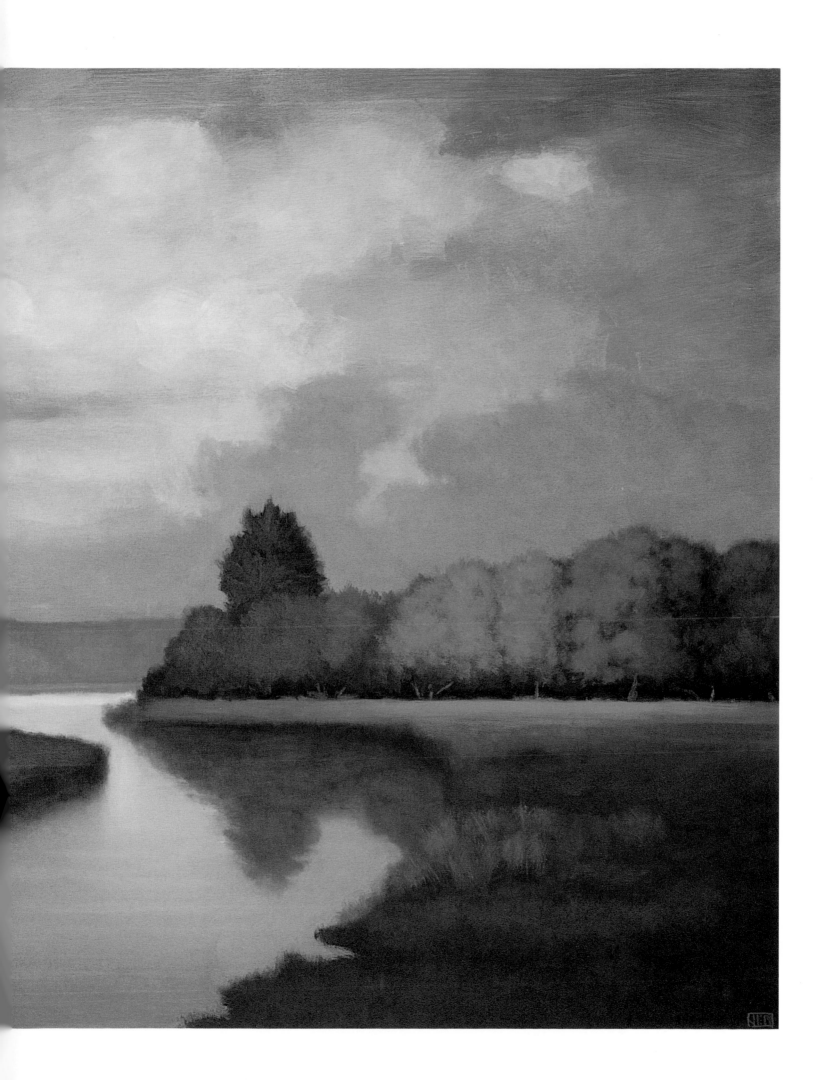

HORSE HILL
OIL ON PANEL I 18 INCHES X 20 INCHES I 2001

PREVIOUS PAGE: LAND AND SKY OIL ON LINEN I 36 INCHES X 60 INCHES I 2000

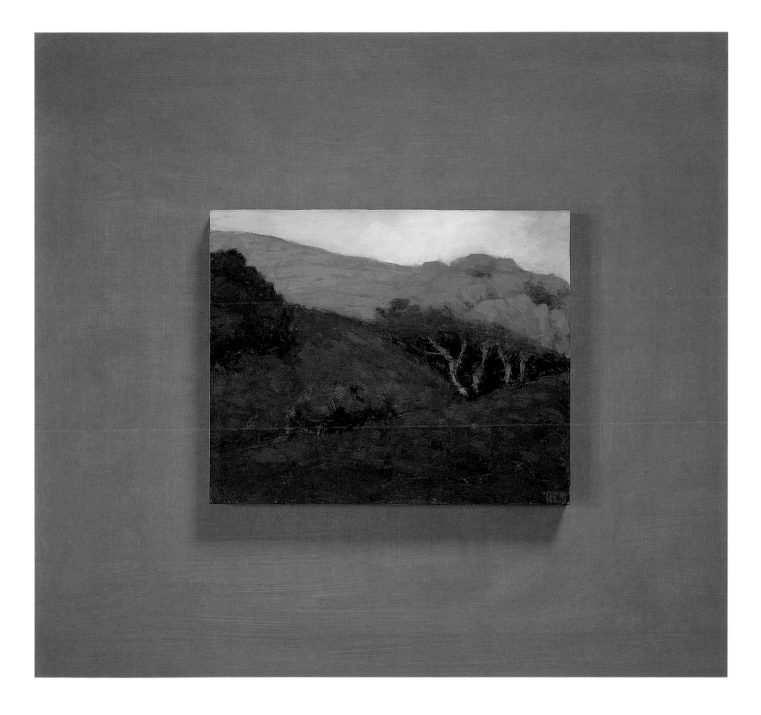

SUMMERTIDE

OIL ON PANEL | 18 INCHES X 20 INCHES | 2001

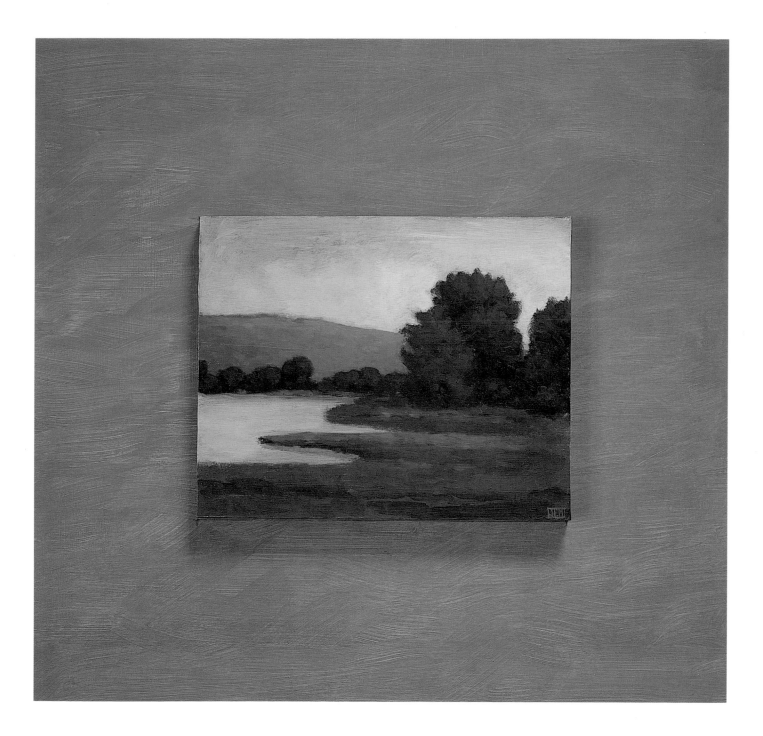

NEAR RING MOUNTAIN
OIL ON PANEL | 18 INCHES x 20 INCHES | 2001

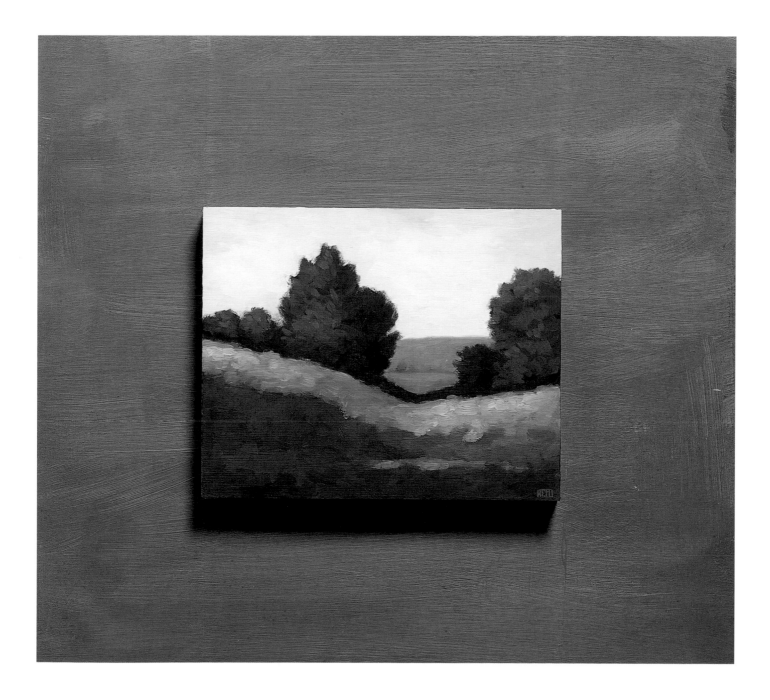

THE MARSHLAND (DETAIL)
OIL ON PANEL | 18 INCHES x 20 INCHES | 2001

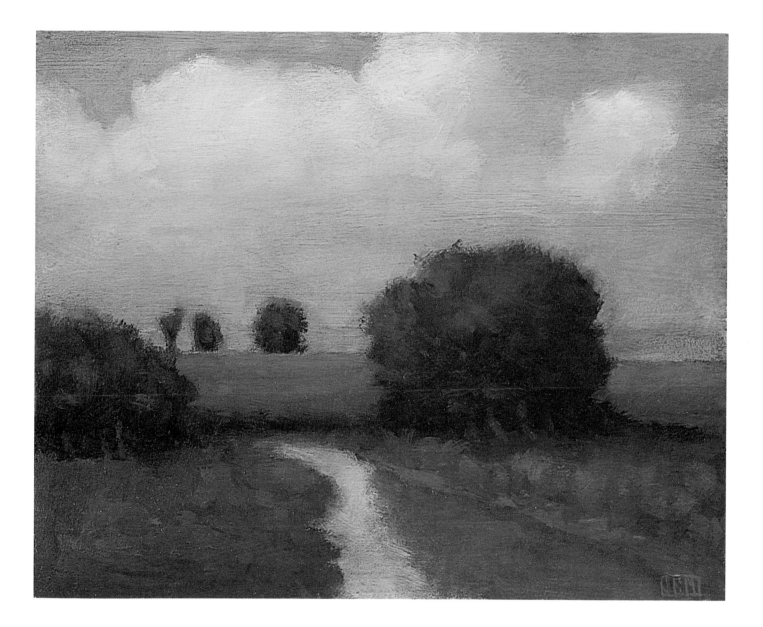

VIEW FROM CORTE MADERA CREEK (DETAIL)

OIL ON PANEL | 18 INCHES X 20 INCHES | 2001

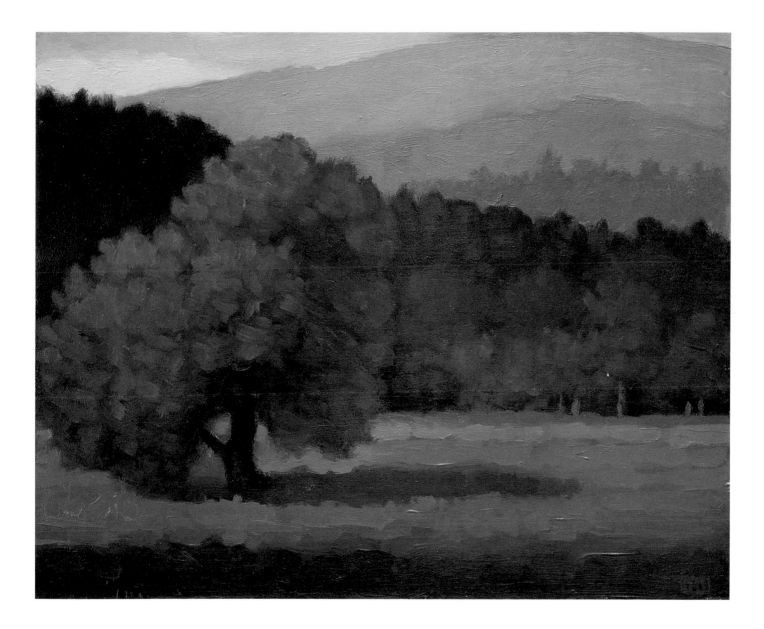

AFTER DIAZ (DETAIL)
OIL ON PANEL ❘ 18 INCHES X 20 INCHES ❘ 2001

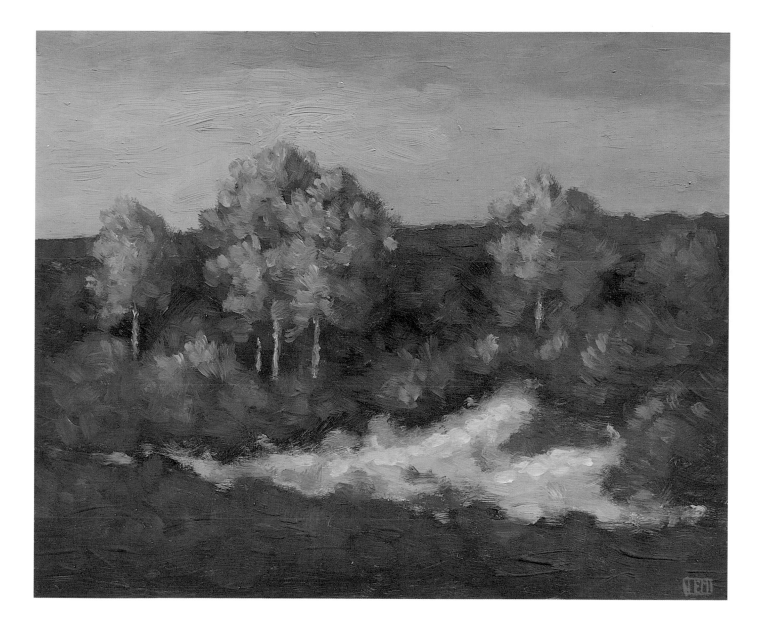

SUMMER POND

OIL ON LINEN | 24 INCHES X 30 INCHES | 2001

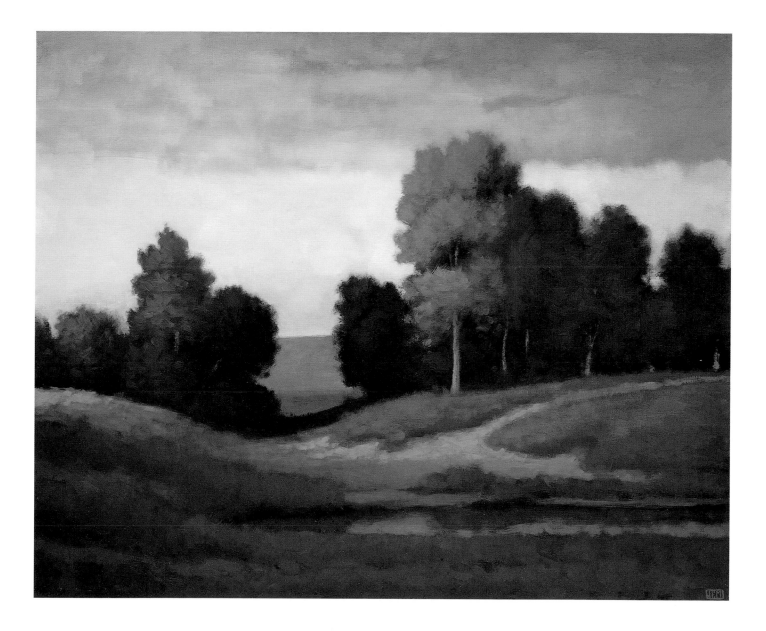

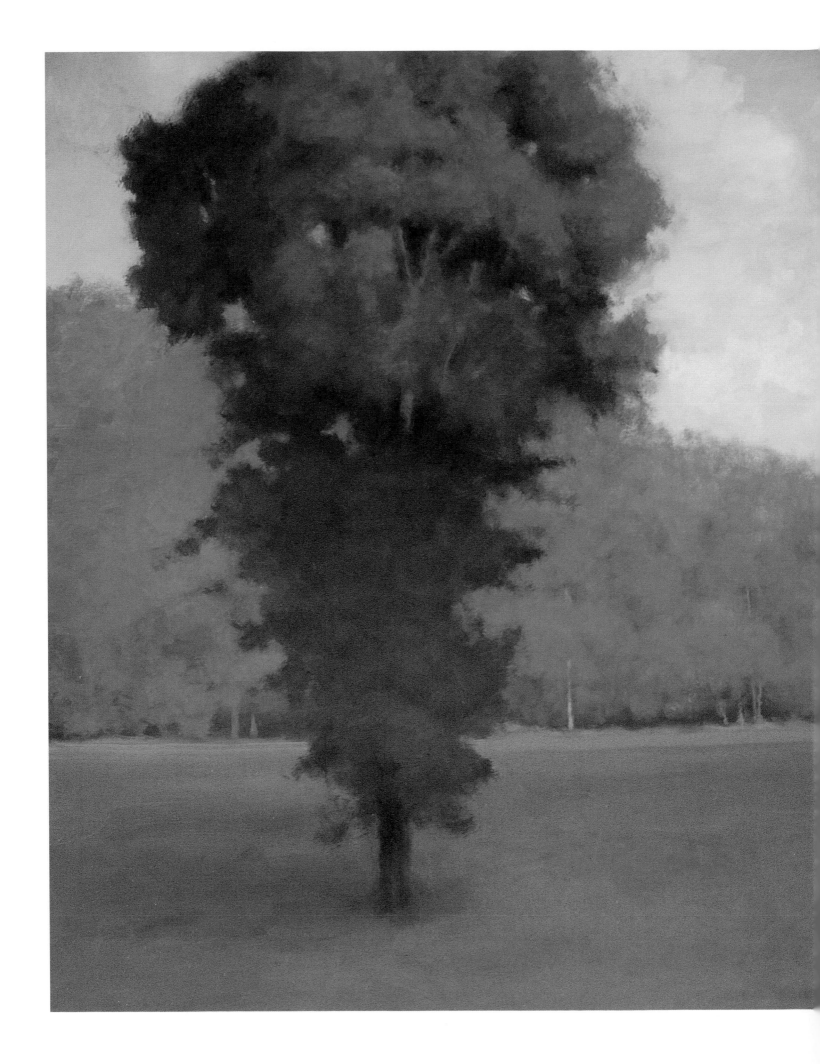

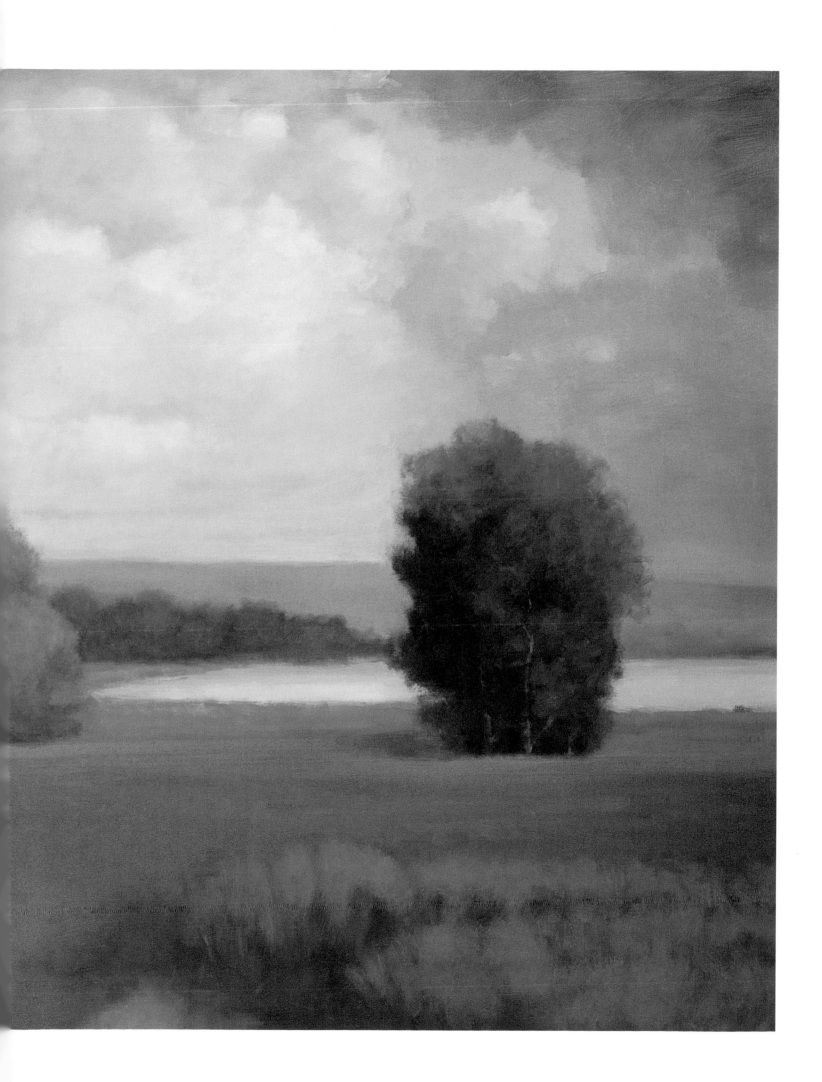

NEAR MUIR BEACH
OIL ON LINEN | 48 INCHES x 48 INCHES | 2001

PREVIOUS PAGE: LOW TIDE OIL ON LINEN | 48 INCHES x 66 INCHES | 2001

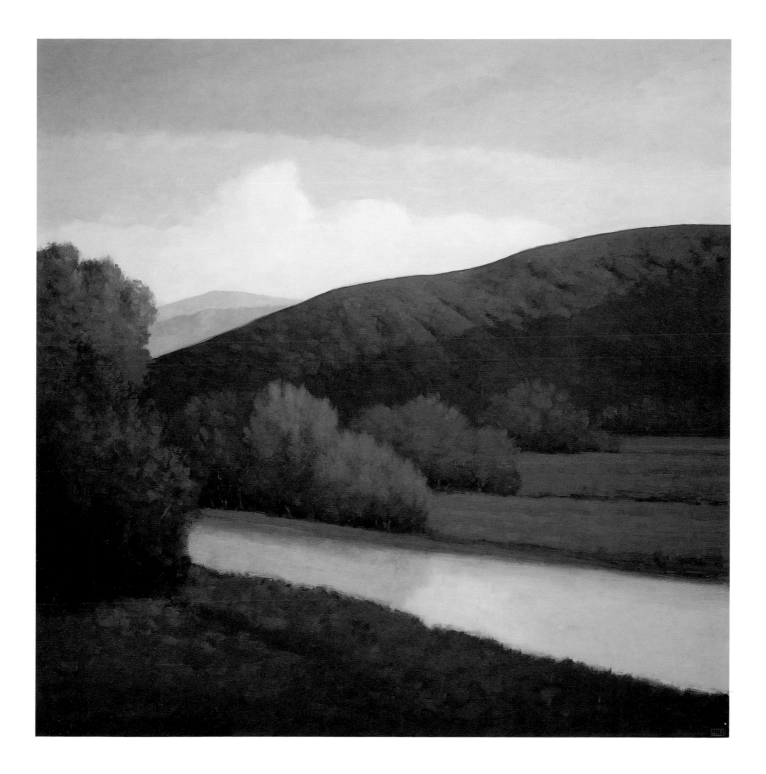

MORNING FOG

OIL ON LINEN ı 36 INCHES x 36 INCHES ı 2001

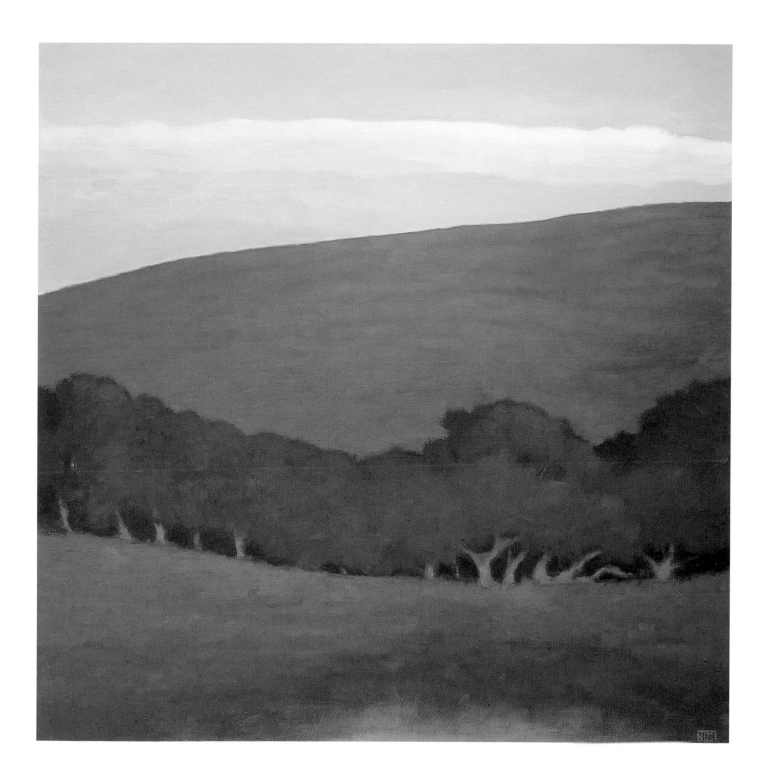

WETLANDS, MORNING

OIL ON LINEN | 30 INCHES x 24 INCHES | 2001

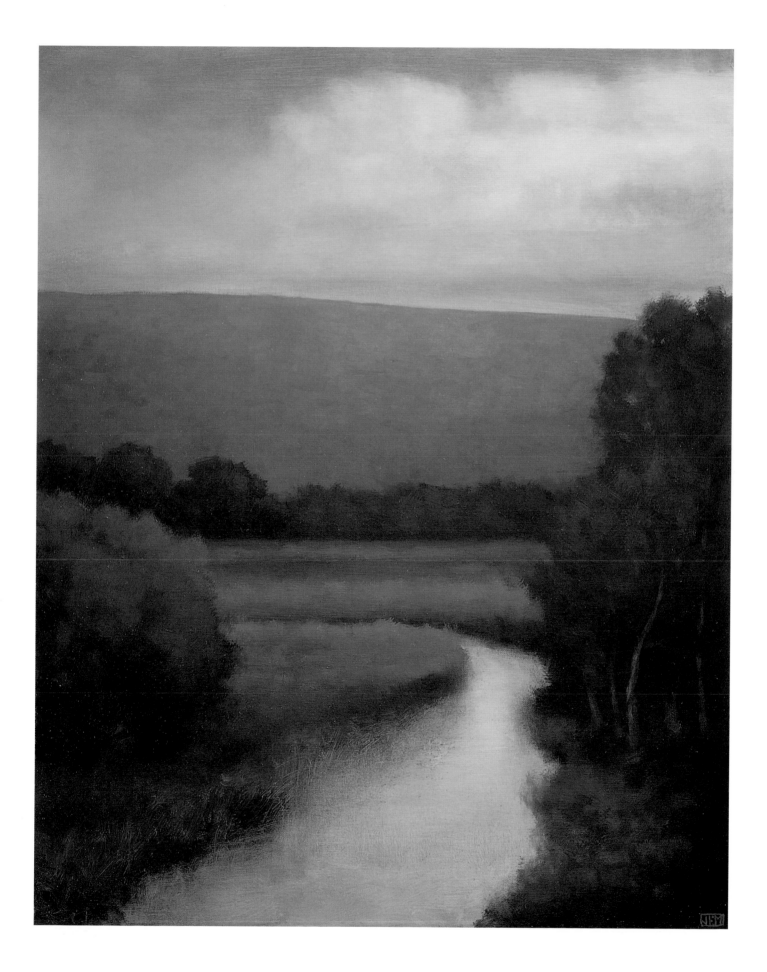

OLEMA

OIL ON LINEN | 24 INCHES x 24 INCHES | 2001

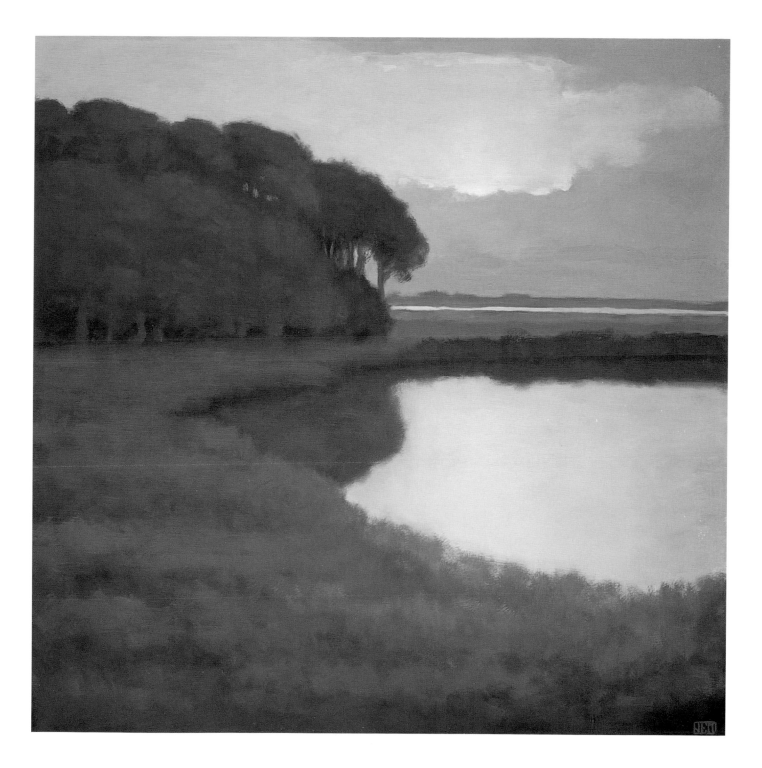

NEAR MARSHALL (TOMALES BAY)

OIL ON LINEN | 48 INCHES x 48 INCHES | 2001

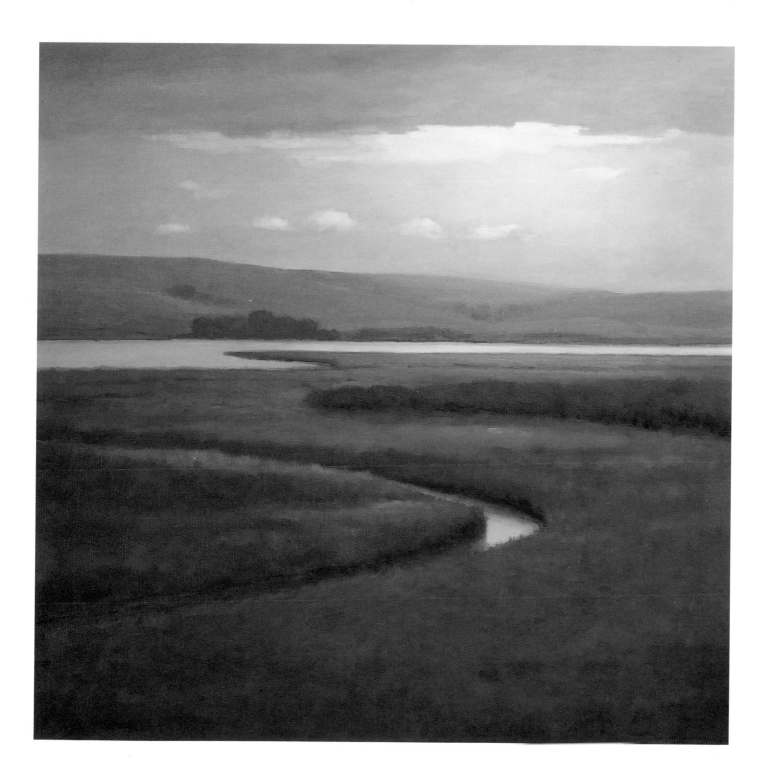

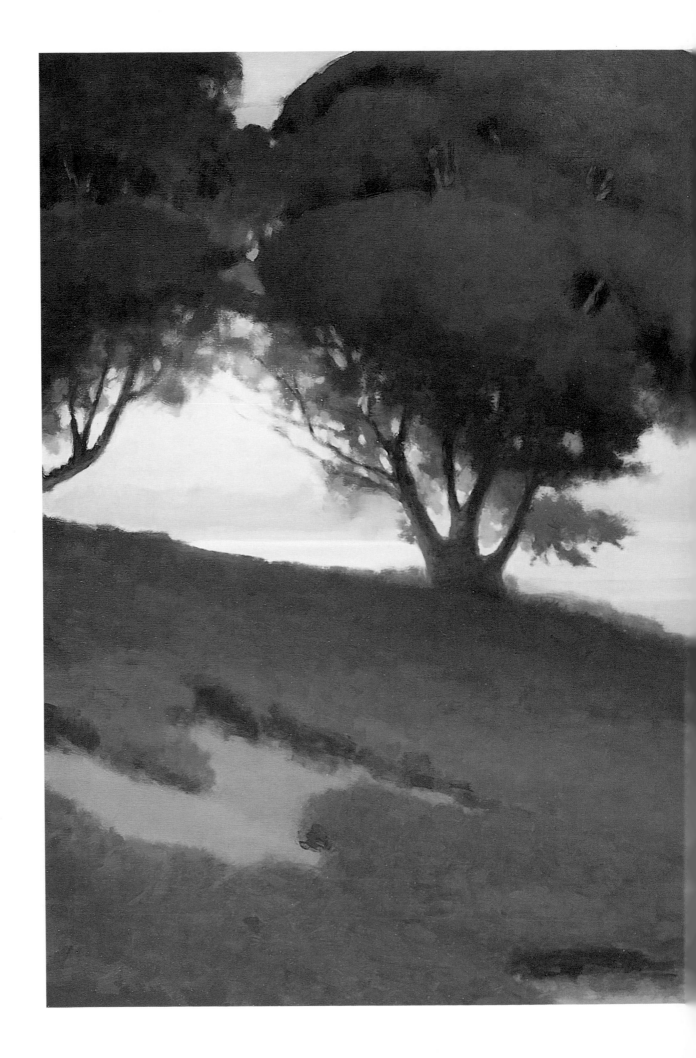

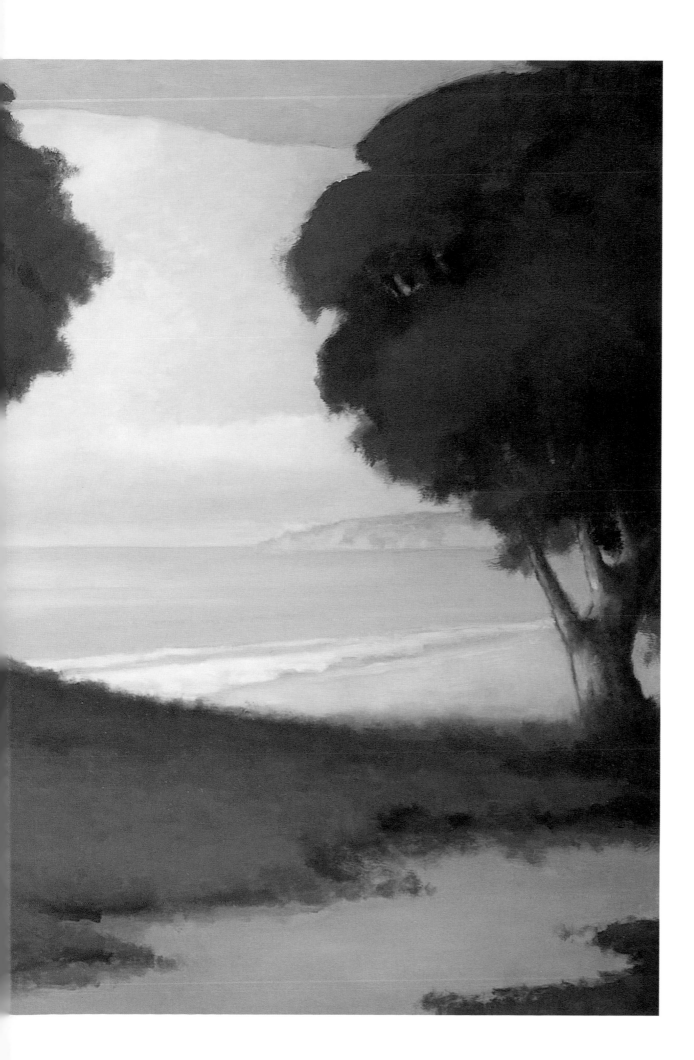

BENDING WATER
OIL ON CANVAS | 48 INCHES X 48 INCHES | 2001

PREVIOUS PAGE: THE SEA AND FOGBANK OIL ON LINEN | 48 INCHES X 60 INCHES | 2001

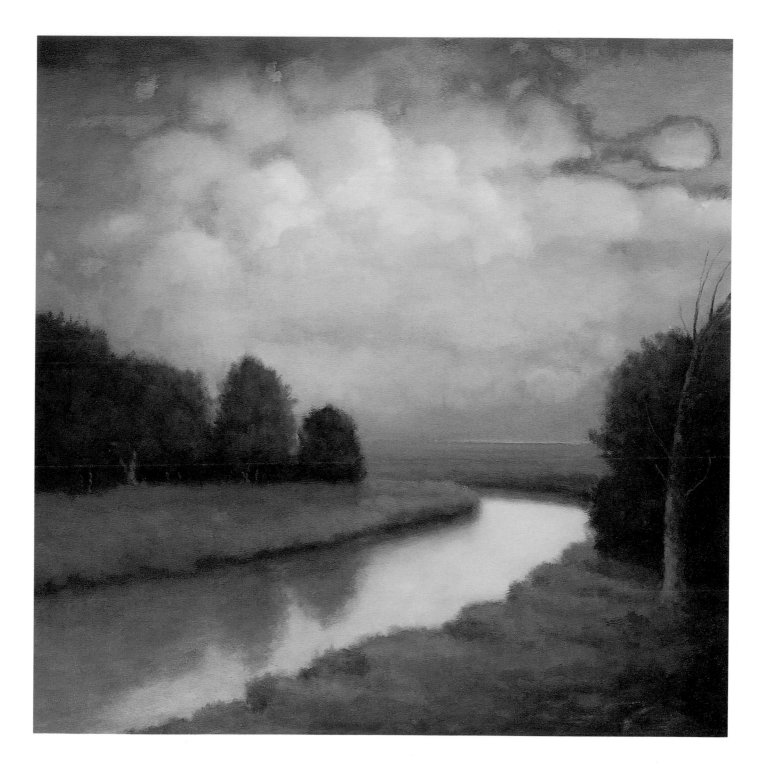

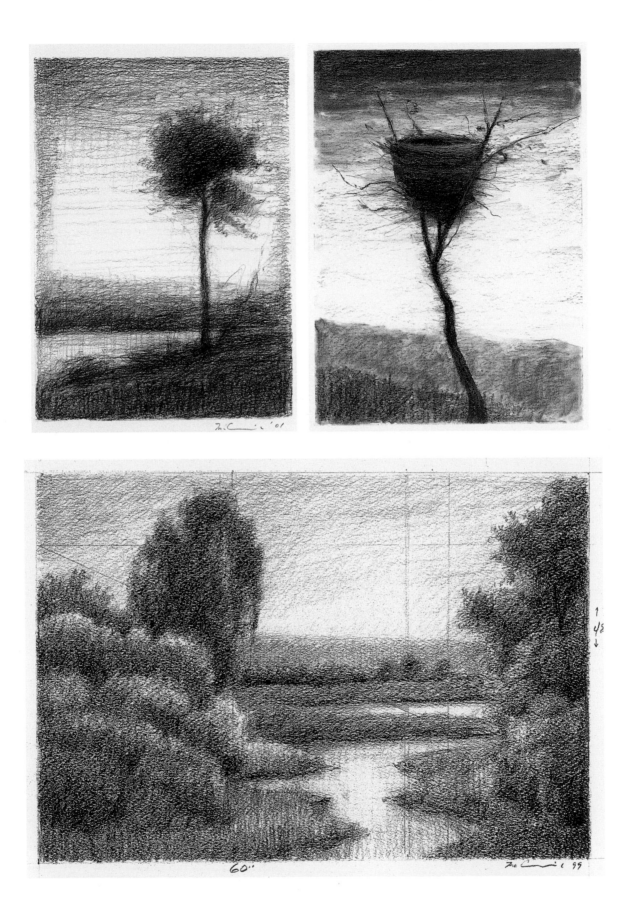

CHARCOAL STUDIES ON PAPER 1994-2001

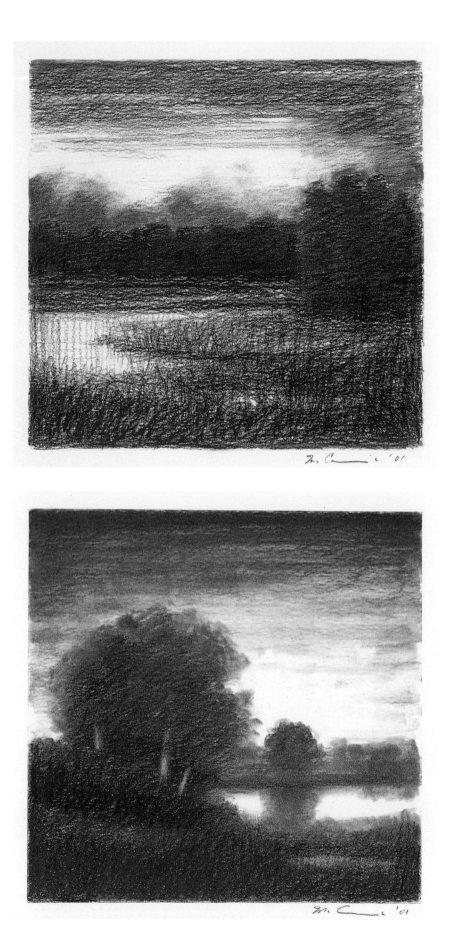

CHARCOAL STUDIES ON PAPER 1994-2001

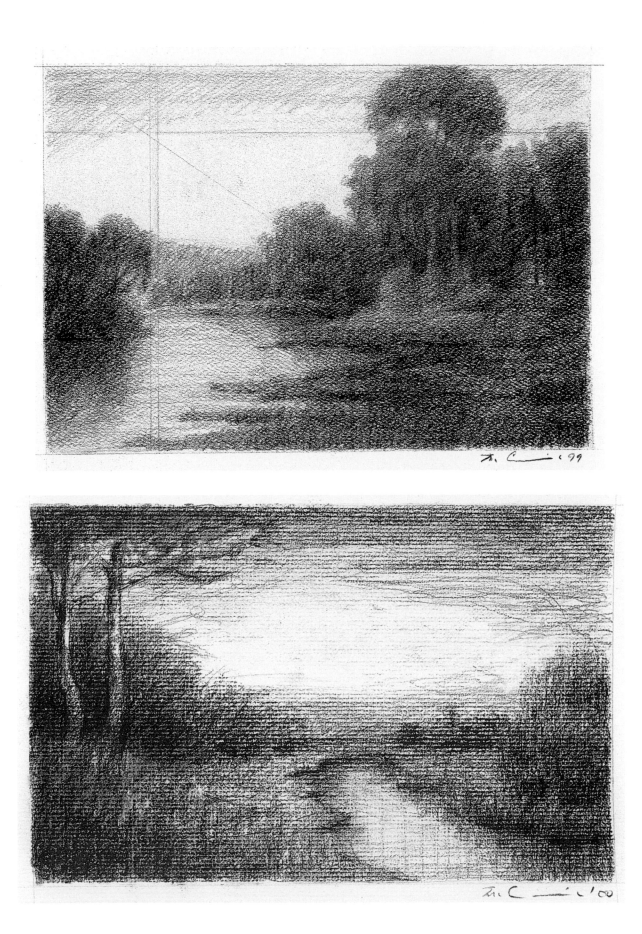

CHARCOAL STUDIES ON PAPER 1994-2001

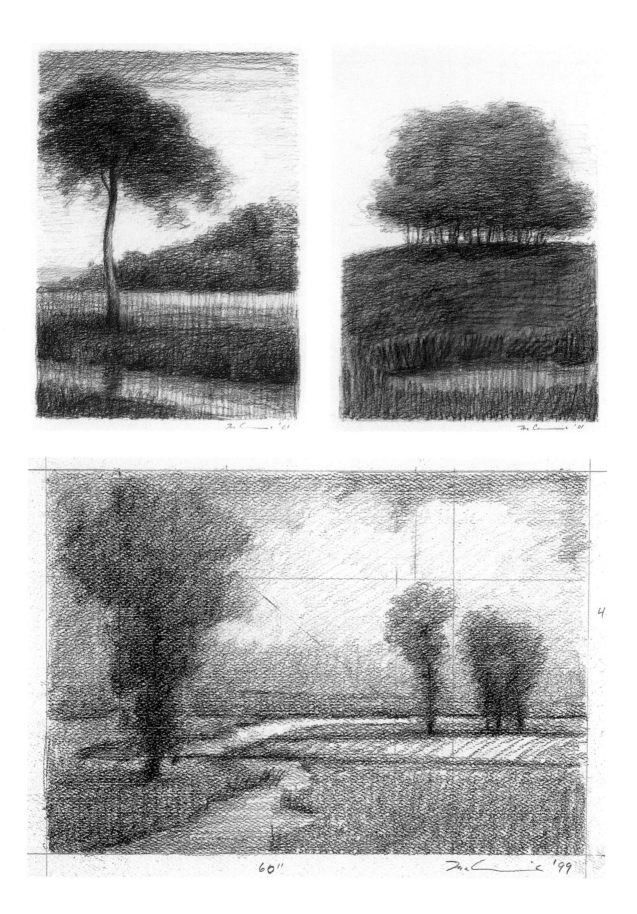

60"

CHARCOAL STUDIES ON PAPER 1994-2001

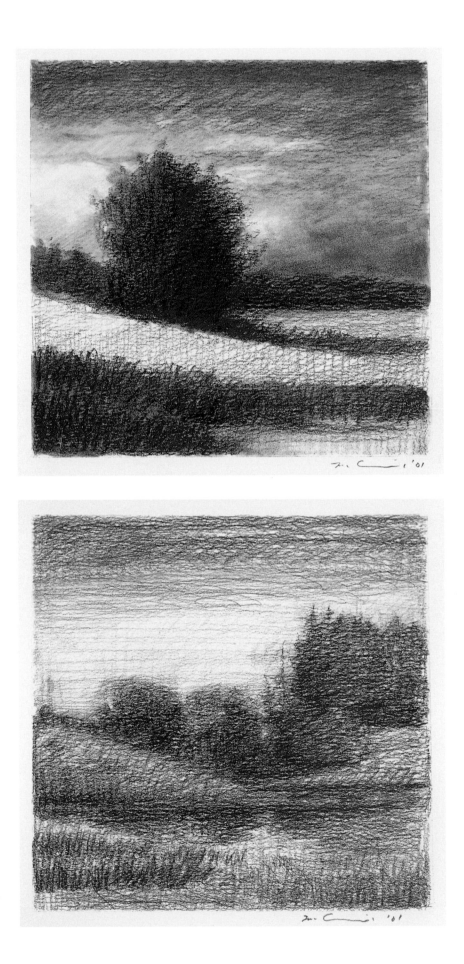

CHARCOAL STUDIES ON PAPER 1994-2001

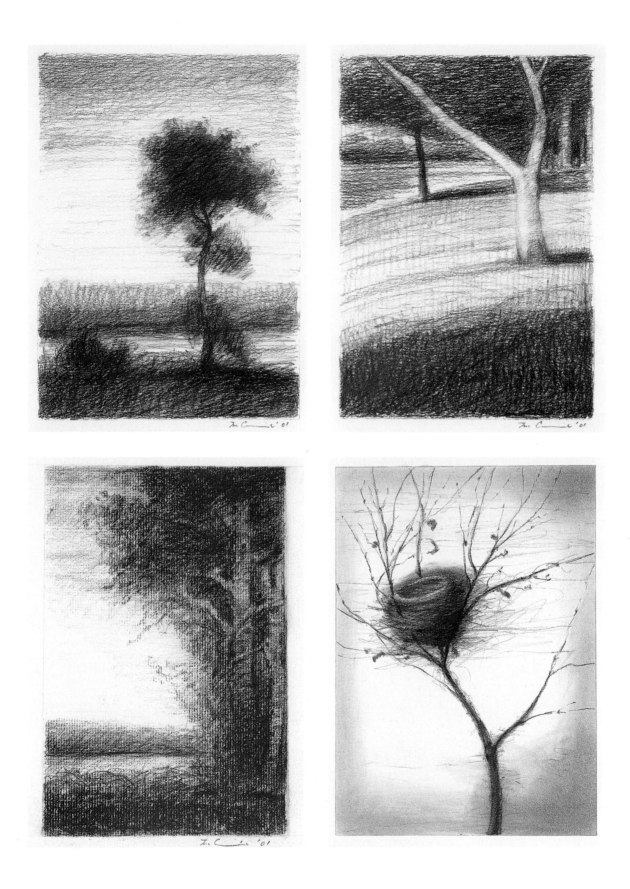

CHARCOAL STUDIES ON PAPER 1994-2001

ACKNOWLEDGEMENTS

I AM GRATEFUL TO ALL THOSE WHO
MADE THIS PROJECT A REALITY.

To Jeffrey Marcus of Marcus Associates who handled the design
of the book with enthusiasm and intelligence.

To Ken Coburn of Global Interprint, whose ideas and knowledge
of printing never cease to overwhelm and amaze me.

To Susan Hillhouse and Ron Glowen for their insightful essays.

To my wife Jan Gauthier for her photography and attention to detail.

To our sons Matthew and Sean, and my parents,
Eugene and Dolores, for their support and sense of humor.

In addition, I would like to thank the following
galleries who have exhibited my work in the United States:
· The Munson Gallery; Santa Fe
· Lisa Harris Gallery; Seattle
· Diane Nelson Fine Art; Laguna Beach
· DNFA Gallery; Pasadena
· The Anne Reed Gallery; Sun Valley
· Robert Allen Fine Art; San Francisco
· Eleanor Ettinger Gallery; New York

THIS BOOK IS DEDICATED TO MY FATHER
WHO SHOWED ME THE MAGIC OF DRAWING.

JOHN McCORMICK
SEPTEMBER, 2001